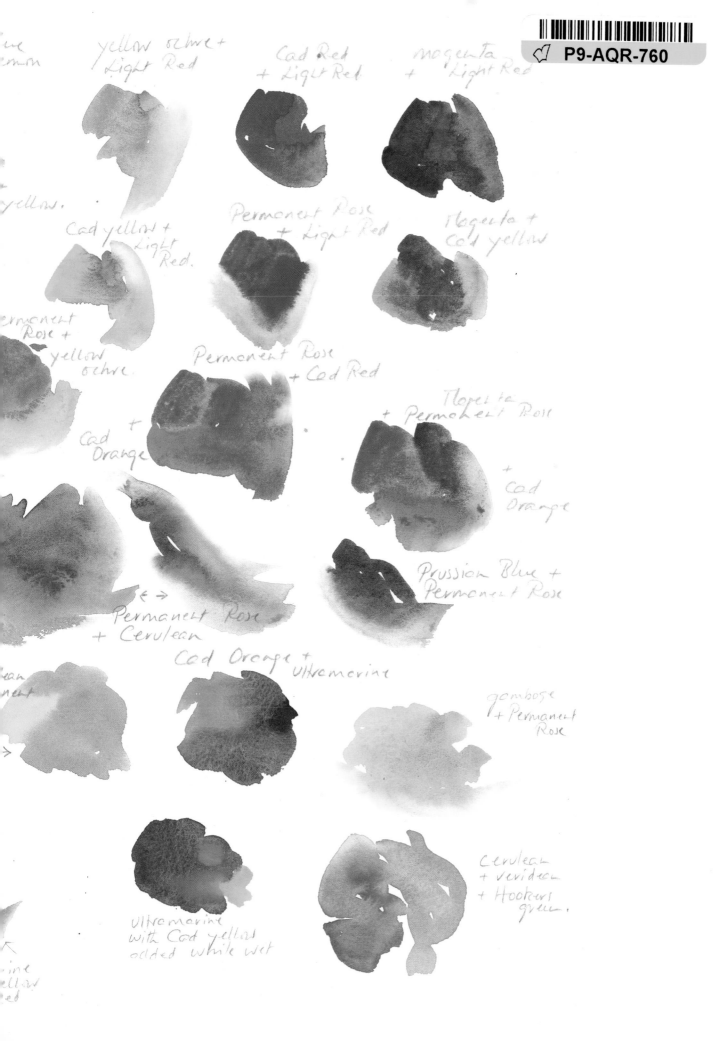

yellow ochre +
Light Red

Cad Red
+ Light Red

magenta
+ Light Red

lemon

yellow.

Cad yellow +
Light
Red.

Permanent Rose
+ Light Red

Magenta +
Cad yellow

Permanent
Rose +
yellow
ochre.

Permanent Rose
+ Cad Red

Magenta
+ Permanent Rose

+
Cad
Orange

+
Cad
Orange

Prussian Blue +
Permanent Rose

← →

Permanent Rose
+ Cerulean

Cad Orange +
Ultramarine

gambose
+ Permanent
Rose

→

Cerulean
+ veridian
+ Hookers
green.

Ultramarine
with Cad yellow
added while wet

Painting flowers

in watercolour

with

Karen Simmons

Dover Publications, Inc., Mineola, New York

*'For thou, Lord, hast made me glad through thy
works: and I will rejoice in giving praise for the
operations of thy hands.'*
Psalm 92, Verse 3

To my children: Rupert, Tim and his wife
Tonya, Rosanne and her husband Chris, and
Oliver, who have been so wonderfully
supportive. With heartfelt thanks to Roz
Dace, whose professional guidance has been
invaluable. Also to Shirley Price for all her
help in converting my handwriting into type.

Published in Canada by
General Publishing Company, Ltd.,
30 Lesmill Road, Don Mills,
Toronto, Ontario.

This Dover edition, first published in 1997, is an
unabridged reprint of the work originally published by
B.T. Batsford Limited,
583 Fulham Road
London SW6 5UA
It is published by special arrangement with the original
publisher.

Dover Publications, Inc.,
31 East 2nd Street
Mineola, N.Y. 11501

Library of Congress Cataloging-in-Publication Data

Simmons, Karen.
 Painting flowers in watercolour / Karen Simmons.
 p. cm.
 ISBN 0-486-29508-7 (pbk.)
 1. Flowers in art. 2. Watercolor painting—Technique.
I. Title.
ND2300.S46 1997
751.42'2434—dc20
 96-41745
 CIP

Preceding pages The Bouquet Honeysuckle
(18 x 24in, 46 x 41cm) *(32 x 20in, 81 x 51cm)*

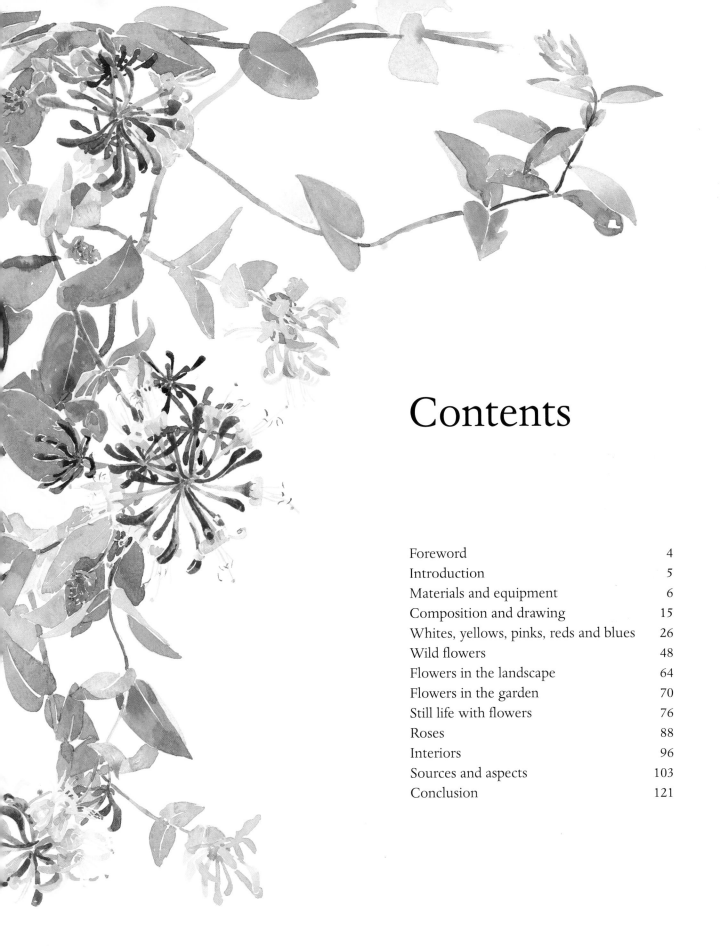

Contents

Foreword

It gives me great pleasure to write this foreword to Karen Simmons' second book. Her enthusiasm and sheer delight for watercolour painting are a joy to see and are clearly evident in her vibrant flower compositions, which positively shimmer with life. Her bold approach to colour and sensitive understanding of how light affects this, and how different pigments behave when mixed together in water, or overlaid in transparent washes, enables her to exploit the special characteristics of the medium to full effect.

Karen also has a well-deserved reputation for her natural teaching skills and ability to inspire and encourage students of all levels. She is generous in how she is prepared to share all aspects of her hard-earned knowledge and experience with students, and untiring in her commitment to inform and guide by breaking down some of the complexities of watercolour painting into methodical and succinctly explained stages. Note her advice on how to plan a composition by making 'plotting diagrams' and her helpful tips about 'blushing' pools of colour to create an appropriate 'underpainting' for developing paintings of flowers in their natural environment – a subject that can present inexperienced painters with all sorts of compositional problems.

Perhaps even more than this, though, Karen's sincerity and dedication to her painting are an inspiration. Like so many of her students, for her painting fulfils a spiritual need. It is, quite literally, life enhancing, her *raison d'être*. This book is an extraordinary achievement by an inspired woman – enjoy, learn, and share Karen's celebration of her life and the world around us through the wonderful medium of watercolour.

Sally Bulgin
Editor, *The Artist*

Introduction

This book is about exploring the full range of subjects that can be 'drawn' from flowers and plants. The artist in each of us makes us aware of our surroundings; we respond as individuals in different ways. This difference provides the rich evidence of the human experience in visual terms. Throughout history, our creativity has revealed our thinking, our beliefs and our aspirations at that time.

Flowers, weeds, seeds, plants and trees have long been a rich source of inspiration to the painter and designer. Architectural detail and decoration have their source of design in nature – for example, the acanthus leaves that decorate the Greek Corinthian columns. Carvings, ironwork, jewellery and crafts of all types reflect man's keen awareness of the flowers and plants around him. There is more to flower painting than a few flowers gracefully arranged in a vase, charming though this subject may be.

Wild flowers growing in their natural habitat jewel their surroundings; chancing on them gives me great joy. To paint flowers is to study them, noting how the light falls on petal and leaf, giving sheen to the colours and glow to the shadows. The stem angles are as nature intended them to be, tilting the flower heads to the light. Even on a stem that has been knocked down, the flower head will turn and revert to the vertical.

Wild flowers grow amongst their own kind, hence the whole field yellow with buttercups, or the wood blue with bluebells. It was noting this that led me to develop the blush technique. I will explain this more fully later on.

Flowers in a garden are another joy for me. It is possible that the flowers have been grouped by a skilful gardener, but are nevertheless standing and growing true to their design. Then there are flowering shrubs and trees and plants whose leaves are of interest in their own right.

A whole range of subjects can be gained from indoor scenes of plants or flowers, or indeed an interior in which the flowers may be incidental to the subject as a whole. Or try looking at flowers with a magnifying glass and making part of the flower your subject, perhaps enlarging a detail to the point of abstraction. This approach is not new; many painters – the most notable being Georgia O'Keefe – have worked in this way.

Just as this book is an exploration of subjects that have their source in flowers, so too is it an exploration of the medium of watercolours. Watercolour can be exploited to describe light-filtered petals and also to imitate the pigmentation found in nature. There are different excitements and problems that arise in each colour group which I have demonstrated in the early chapters. I have also discussed an approach to drawing and planning work that I find helpful.

Above all else, this book is a homage to paintings that are inspired by flowers.

Materials and equipment

There is now a bewildering array of materials to choose from. The aim is to have what you need for the job rather than paints and equipment for every eventuality.

It is important to be physically comfortable whether you are working indoors or out. I do use an easel and prefer to stand with the tilt of the easel nearly flat. This enables me to keep a lot of wet paint flowing. If I sit, I try to sit with a straight back; this is far less tiring than crouching over the work.

When I want to carry the absolute minimum, I take a couple of dustbin bags – one to sit on and one to place my materials on. I use the following equipment at one time or another, although not necessarily the whole lot at any one time.

1 Easel I like to stand to paint and prefer an easel that I can angle and tilt.

2 Stool Something I occasionally use. (Not illustrated.)

3 Dustbin bags One which I sit on when I am painting outdoors and one to lay my paints and brushes on so that I do not lose any small item of equipment in the long grass.

4 Support board A wooden drawing board may be too heavy so I use a cheap canvas board.

5 Paper Most of the paintings in this book have been painted on Bockingford 140lb (300gsm). I like it because it is very white and luminous and the surface has sufficient tooth and size to allow the pigment to granulate, which provides the suggestion of texture.

6 Clips To secure the paper to the board.

7 Wet cloth This I find most helpful if painting in the hot sun. I place a damp white linen rag under the paper. The water from the rag gradually evaporates, slowing down the drying time of the paints and allowing them to 'pool' for longer.

8 A hat to keep the sky glare off when working out of doors.

9 Brushes I like a fat brush with a good point, so I use a size 24, 14, 10, a square flat of ½in and 1 in, and also a squirrel mop brush. My brushes are either synthetic or mixed. For the larger sizes, sable is not really necessary because the brush holds plenty of water and pigment. If you are using very fine brushes, a sable will hold more pigment than the equivalent size in synthetic.

10 Pencils For preparatory drawings I prefer a soft pencil – 3b, 4b or 5b. This glides easily across the paper and leaves no dent in the paper as a harder lead might do. For botanical detail, however, a firmer lead is preferable.

11 Magnifying glass This opens your eyes to new aspects and ideas when exploring and painting the inner secrets of a flower.

12 Flower separator This keeps the stem at its most natural angle if you need to pick a flower and work indoors. I use a heavy lead nail separator.

Materials

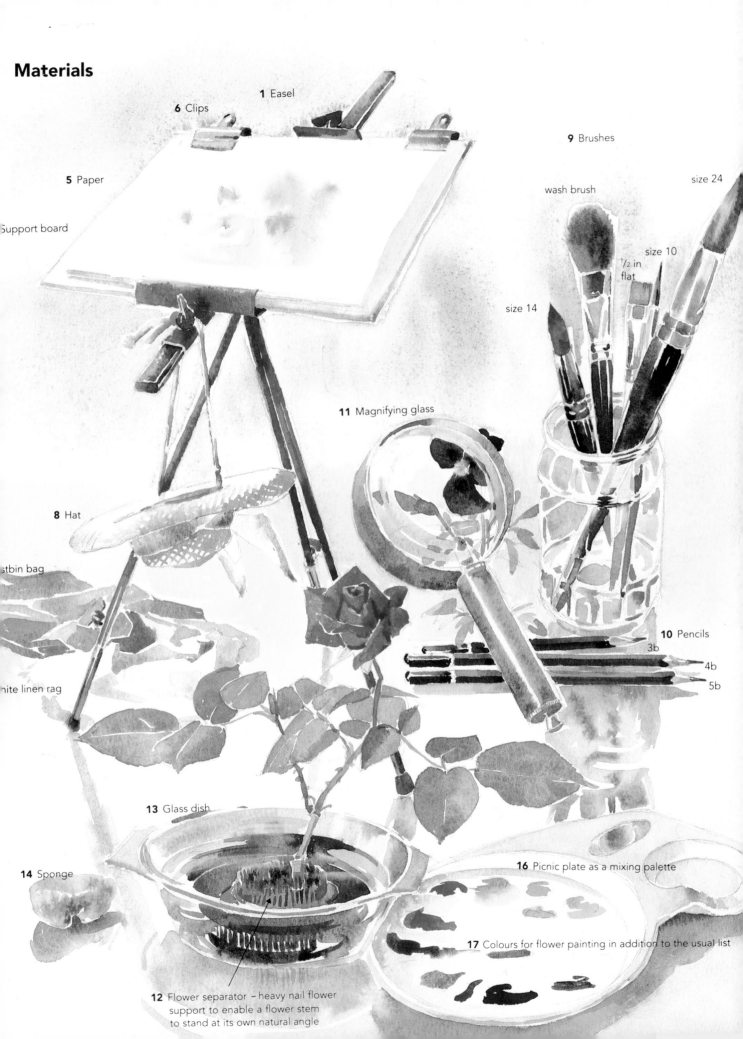

1 Easel

6 Clips

5 Paper

Support board

9 Brushes

size 24

wash brush

size 10

½ in flat

size 14

8 Hat

stbin bag

hite linen rag

11 Magnifying glass

10 Pencils

3b

4b

5b

13 Glass dish

14 Sponge

16 Picnic plate as a mixing palette

17 Colours for flower painting in addition to the usual list

12 Flower separator – heavy nail flower support to enable a flower stem to stand at its own natural angle

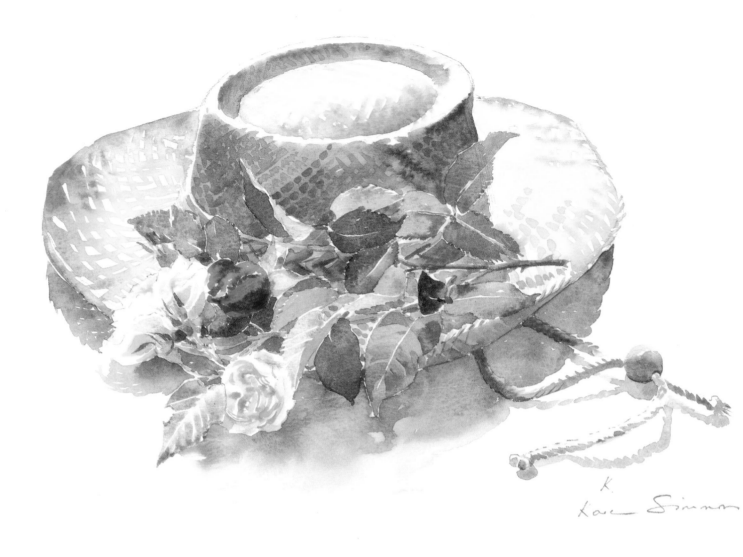

Australian hat
(12½ x 16½ in, 32 x 42cm)
My straw hat with a few flowers.

13 A glass dish For holding the flower separator without obscuring the stem.

14 Sponge This is not for use on the work but to absorb the surplus paint on your brush from time to time. Kitchen paper does just as well.

15 Paints I use pans for flowers as I am using small quantities of each colour. I choose the most transparent paints available. (Paint box not illustrated.)

16 Mixing palette In addition to the area on the paint box I have a mixing palette – it is actually a cheap picnic plate.

17 Colours Despite a general armoury of twenty-one colours, I do restrict my palette within each painting. The colours I choose depend on the subject. Some of the colours described opposite are essential for flower painting but not necessary for landscape painting.

The choice between tubes and pans depends on your method of painting. For flower painting I use pans, for I need only a small quantity of a colour at a time. Pans have the advantage of keeping their moistness for years. The advantage of tubes is that you can mix a generous amount of paint more easily and this is

convenient when working on a larger scale. Tube paints do dry out, though, and unless you use the quantities squeezed out within a day or two they will harden. For this reason I do not recommend filling empty pans with tube paint.

My palette

I find these twenty-one colours (see also overleaf) necessary to convey the vibrant variety of colour to be met with in nature. Using artists' quality paint is worthwhile, for as these are stronger you need less of the pigment. I do have a preference for transparent watercolours so I use Rowney artists' quality pans.

1 **Cadmium Yellow Pale** – a transparent lemon yellow.

2 **Cadmium Yellow** – a good bright buttercup yellow.

3 **Aureolin** – very clear pale yellow with a greenish tinge.

4 **Gamboge** – a delightful strong yellow which dilutes usefully.

5 **Raw Sienna** – a transparent version of Yellow Ochre.

6 **Yellow Ochre** – opaque, and tends to separate from any colour it is mixed with. This can be advantageous when needing a textured effect.

7 **Cadmium Orange** – a useful extra for flower painting.

8 **Cadmium Red** – a bright strong red which can replace vermilion.

9 **Vermilion** – a more expensive, bright strong red.

10 **Permanent Rose** – a sharp clear pink. Rose Madder is a similar pink. Only the pure colour will enable you to mix the violets, mauves and purples.

11 **Permanent Magenta** – so many flowers do require just this sharp purpley pink that no other combination can make.

12 **Cobalt Violet** – similar to Permanent Magenta but a shade more blue.

13 **Crimson Alizarin** – a beautiful ruby red but heavy. It can dry disappointingly. I hardly ever use it.

14 **Cerulean Blue** – Also opaque. Like Yellow Ochre, it will separate from any colour it is mixed with allowing the paper to show through and giving a textured effect. When mixed with Permanent Rose an exciting vibrant violet can result.

15 **Cobalt Blue** – a smooth true blue.

16 **French Ultramarine Blue** – a strong bright blue which does separate. On its own it will spread awkwardly in water but when mixed with a tiny amount of another colour it will behave perfectly.

17 **Permanent Blue** – half way between Ultramarine Blue and Prussian Blue – very lively.

18 **Prussian Blue** – a strong greeny blue which makes a magnificent rich purple when mixed with Permanent Rose.

19 **Light Red** – a reddish brown which dilutes to near pink.

20 **Raw Umber** – a neutral brown with a greenish tinge. Very useful for making greys; can be mixed with Cerulean for a warm grey or Ultramarine for a cool grey.

21 **Madder Brown** – a dramatic, rich, dark red brown useful for some stems or centres of flowers.

My palette

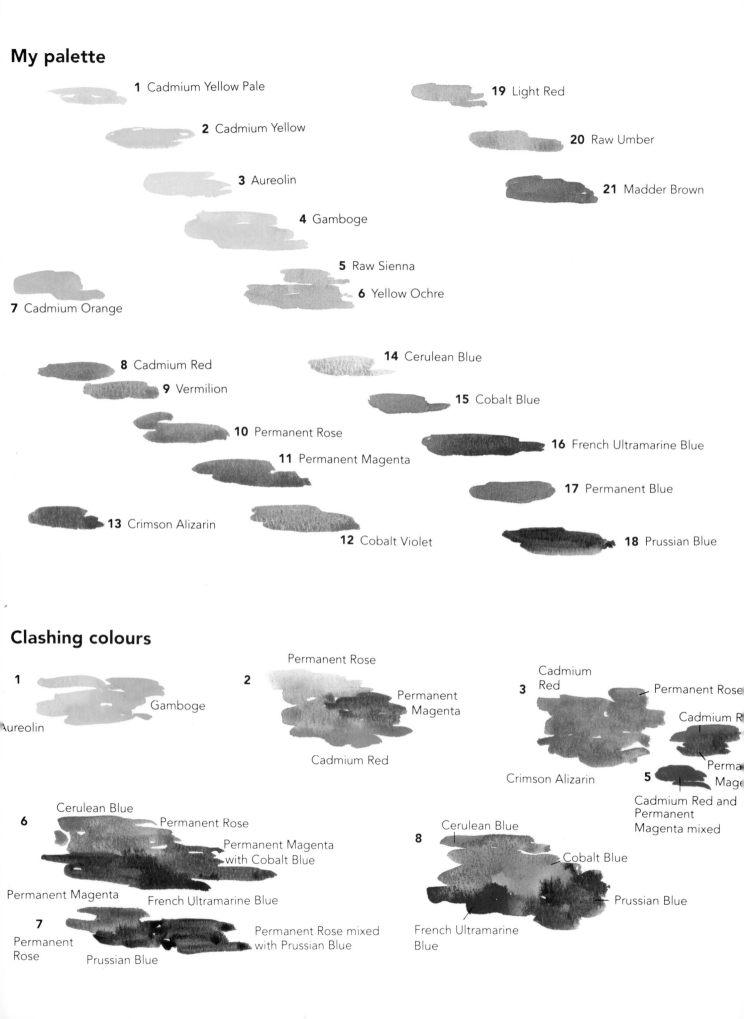

1 Cadmium Yellow Pale

2 Cadmium Yellow

3 Aureolin

4 Gamboge

5 Raw Sienna

6 Yellow Ochre

7 Cadmium Orange

8 Cadmium Red

9 Vermilion

10 Permanent Rose

11 Permanent Magenta

13 Crimson Alizarin

12 Cobalt Violet

19 Light Red

20 Raw Umber

21 Madder Brown

14 Cerulean Blue

15 Cobalt Blue

16 French Ultramarine Blue

17 Permanent Blue

18 Prussian Blue

Clashing colours

1

Aureolin

Gamboge

2

Permanent Rose

Permanent Magenta

Cadmium Red

3

Cadmium Red

Permanent Rose

Cadmium R

Crimson Alizarin

Perma
Mage

5

Cadmium Red and
Permanent
Magenta mixed

6

Cerulean Blue

Permanent Rose

Permanent Magenta
with Cobalt Blue

Permanent Magenta

French Ultramarine Blue

7

Permanent
Rose

Prussian Blue

Permanent Rose mixed
with Prussian Blue

8

Cerulean Blue

Cobalt Blue

Prussian Blue

French Ultramarine
Blue

Clashing colours

The excitement of watercolour lies in being able to lay two or three colours side by side and letting them bleed together into a partial mix. The effect is far more vibrant than simply mixing those same colours together. Nature clashes colour so we need to clash the colours too, in order to convey the same vibrancy (see opposite, below). When closely observed, the fall of light together with the shadows will give opportunities for clashing the colours.

1 **Aureolin partially mixed with Gamboge** can be fresh and lively.
2 **Permanent Rose amplified with Permanent Magenta** is then clashed with Cadmium Red.
3 **Cadmium Red clashing with Permanent Rose** deepened disappointingly with Crimson Alizarin.
4 **Cadmium Red clashed richly with Permanent Magenta.**
5 **Cadmium Red mixed together with Permanent Magenta** will give a lovely intense dark red.
6 **Cerulean Blue partially mixed with Permanent Rose** makes a lively violet. Permanent Rose with Cobalt Blue creates a lovely purple. Permanent Magenta with French Ultramarine Blue results in a richer mixture still.
7 **Permanent Rose clashed with Prussian Blue** and mixed together to make the richer purple.
8 **Cerulean Blue side by side with Cobalt Blue, Prussian Blue and French Ultramarine Blue** together make an impact of vibrant blues.

Shadow colours

The best guidance for choosing the 'right' shadow colour for flowers is observation. Shadows are not always caused by a solid interruption to the light; a translucent petal or leaf can cause them. The light coming through a petal or leaf can have a stained glass window effect, which amplifies the colour. When observed and painted, this effect can add precious luminosity to the painting (see page 13).

The shadow colour for yellows is a notoriously hazardous area.

For pale yellow flowers, for example, daffodils, sandpoppies and primroses, a blue mauve using Cobalt Blue and a trace of Permanent Rose when laid over the pale yellow will soften to a translucent grey. Sometimes I drop the colour into the wet yellow; other times I wait for the yellow to dry, then glaze over.

For deeper yellows, the shadow colour can be made from a red mauve mixed from Permanent Rose with a little Cobalt Blue. This colour mixture when laid over the yellow makes a rich bronze colour keeping the flower healthy and lively (see *Sunflowers*, page 35).

Pink and red flowers may get cooled or bleached by a strong light but, where the light penetrates, a richer warmer red can be observed. If pinks are shadowed by a blue purple, the flower looks as if it is about to die. Some outer petals with a cast

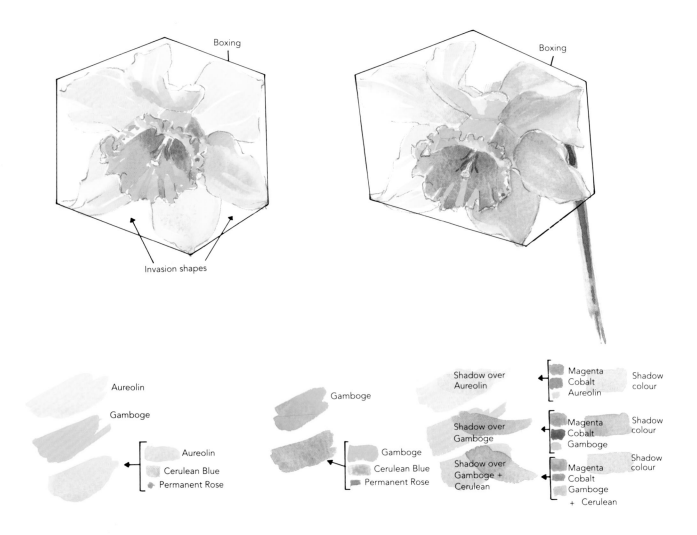

Daffodils and their Shadow Colours

The daffodil heads show the boxing and invasion shape approach to achieving an accurate drawing when presented with any angle. The detailed colour mixes opposite (top) convey the shadow colours for the different yellows in the petal and trumpet of the daffodil.

Colours used: *Aureolin, Gamboge, Permanent Rose, Permanent Magenta, Cerulean Blue and Cobalt Blue.*

Paper: *Bockingford 140lb/300gsm.*

shadow may indeed show a mauve colour. Bougainvillaea, geraniums and tulips look better when the pink is shadowed with red.

A light Cadmium Red can be deepened with a denser mixture of Cadmium Red and Permanent Rose.

Cadmium Red is clashed with Permanent Magenta, then darkened further by the two colours mixed together.

A blue delphinium might be shadowed with a red blue made with Permanent Rose mixed with French Ultramarine Blue.

Some greens

An endless variety of greens can be made using the yellows and blues that are available (see page 13).

Cadmium Yellow Pale with Cerulean Blue will granulate to a fresh salad green.

A heavier richer green can be made using Cadmium Yellow with French Ultramarine Blue.

Shadow colours

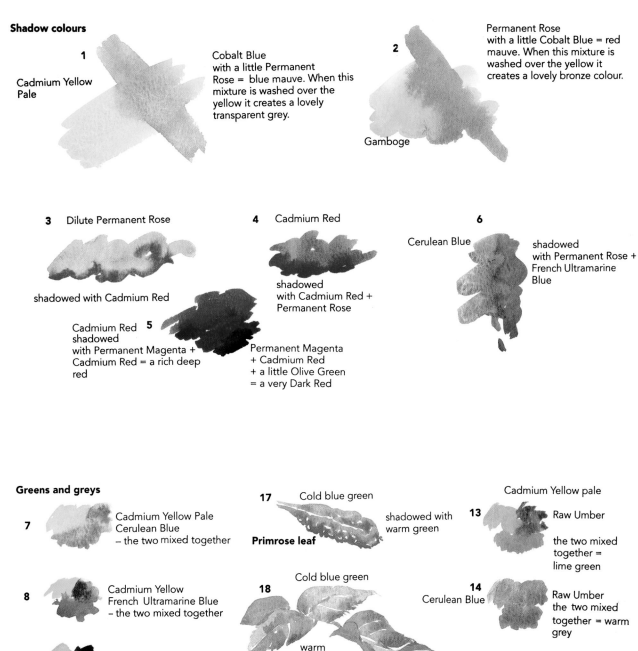

1

Cadmium Yellow Pale

Cobalt Blue with a little Permanent Rose = blue mauve. When this mixture is washed over the yellow it creates a lovely transparent grey.

2

Permanent Rose with a little Cobalt Blue = red mauve. When this mixture is washed over the yellow it creates a lovely bronze colour.

Gamboge

3 Dilute Permanent Rose

shadowed with Cadmium Red

Cadmium Red shadowed with Permanent Magenta + Cadmium Red = a rich deep red **5**

4 Cadmium Red

shadowed with Cadmium Red + Permanent Rose

Permanent Magenta + Cadmium Red + a little Olive Green = a very Dark Red

6

Cerulean Blue

shadowed with Permanent Rose + French Ultramarine Blue

Greens and greys

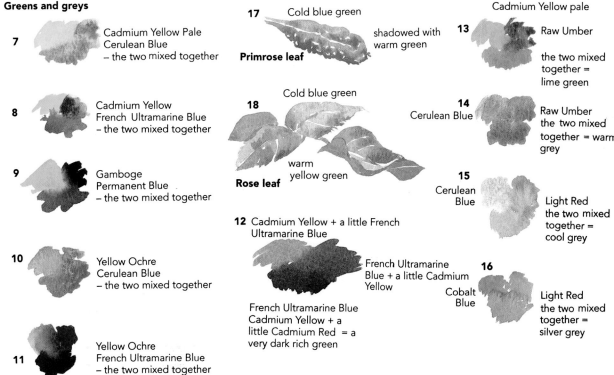

7 Cadmium Yellow Pale Cerulean Blue – the two mixed together

8 Cadmium Yellow French Ultramarine Blue – the two mixed together

9 Gamboge Permanent Blue – the two mixed together

10 Yellow Ochre Cerulean Blue – the two mixed together

11 Yellow Ochre French Ultramarine Blue – the two mixed together

17 Cold blue green

shadowed with warm green

Primrose leaf

18 Cold blue green

warm yellow green

Rose leaf

12 Cadmium Yellow + a little French Ultramarine Blue

French Ultramarine Blue + a little Cadmium Yellow

French Ultramarine Blue Cadmium Yellow + a little Cadmium Red = a very dark rich green

Cadmium Yellow pale

13 Raw Umber

the two mixed together = lime green

14 Cerulean Blue Raw Umber the two mixed together = warm grey

15 Cerulean Blue

Light Red the two mixed together = cool grey

16 Cobalt Blue

Light Red the two mixed together = silver grey

Gamboge and Permanent Blue give a bright rich green.

Yellow Ochre and Cerulean Blue combined granulate, giving a very useful textured effect.

Yellow Ochre and French Ultramarine Blue also give a textured effect and create a darker sombre green.

For a really dark green, the addition of a little Cadmium Red will enrich without spoiling the colour.

Yet another green, a lime green, can be made using Cadmium Yellow Pale with Rowney Raw Umber.

Some greys

Cerulean Blue and Raw Umber combine to make a useful warm grey. I frequently use this in landscapes.

Cerulean Blue mixed with Light Red creates a beautiful cool grey – marvellous for olive trees!

Light Red mixed with French Ultramarine Blue creates a silvery grey. Varying the mixtures will give even more subtle greys.

The primrose leaf is an example of using cold and warm greens to shape and texture the leaf.

Using the different greens describes the form and tilt of the rose leaves. Cold greens are ones that are predominantly blue; the warmer greens have more yellow in their mixture.

Primroses in a Glass Jug
(7 x 9in, 19 x 23cm)
The range of greys in this little painting were created using Cobalt Blue, Permanent Rose and Cadmium Yellow Pale. On the primrose petals the delicate blue mauve was laid over the Cadmium Yellow Pale making a lovely, luminous grey shadow. For the vase and the foreground shadows, the mauve was mixed with a little Cadmium Yellow Pale in varying strengths. The resulting greys were in harmony with each other.
Colours used: *Cadmium Yellow Pale, Gamboge, Permanent Rose, Cerulean Blue and Cobalt Blue.*
Paper: *Bockingford 140lb/300gsm*

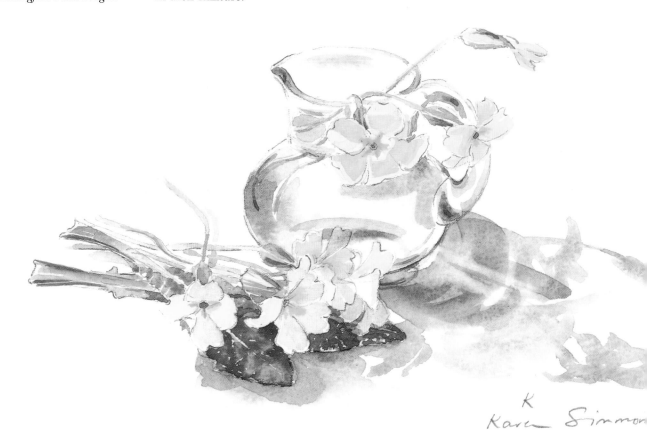

Karen Simmons

Composition and drawing

Composition is the composing of the various parts of your chosen subject and how to place your subject to best advantage on the given page. But what is your subject? All too often, with time being scarce, we rush into a painting with too little thought. We grab what is there in front of us instead of selecting that part which truly interests us the most. A stage director groups his cast, arranges the props and uses the lighting the better to tell the story. We need to do the same.

It is worthwhile to pause and analyze exactly what your story is:

- is it the vase of flowers?
- or one or two of the flowers?
- is the vase interesting?
- are there shadows or reflections?
- where is the lighting coming from? Light full on to the subject can look bland; some shadow is helpful. A subject against the light can be dramatic.

In addition, ask yourself:

- is the subject best suited to a vertical (portrait) page or a horizontal (landscape) page? It is worth doing a few sketches to see which format works best.
- what part of the subject do you regard as the focal point – the heart and meaning of the painting? Deciding this helps build a good composition and saves disappointment. I am aware that some of you might mutter: 'If I did all that I would never get anything done.' Well, with experience, you can think through these various stages envisaging their possibilities.

The compositional device known as the Golden Section or Golden Proportion is often used when a serene, reassuring composition is wanted. The ancient Egyptians were known to have used it and the Greeks found a mathematical formula for it. This Golden Proportion exists widely in nature – in shells, snowflakes and the human body – so that consciously or unconsciously we are comfortable with it.

The Golden Section or Golden Proportion (see overleaf) is that division of a line in which the smaller part is in the same proportion to the greater part as that greater part is to the whole. This proportion was fundamental in the structure and composition of *The Dresser* (page 101). I have also used it in the sketch (page 18).

A vase of flowers presents the painter with some compositional hazards (see overleaf). If the vase is placed on a table and the painter is sitting down, the view is decidedly over vased, more so if the vase is made to look too close to the edge of the table. This situation can arise when a group is working together and the viewpoint is not the painter's choice.

The Golden Proportion

This is a definite measurement. It is that division of a line in which the smaller part is in the same proportion to the greater part as that greater part is to the whole. In other words, the golden section is at B when $\dfrac{BC}{AB} : \dfrac{AB}{AC}$

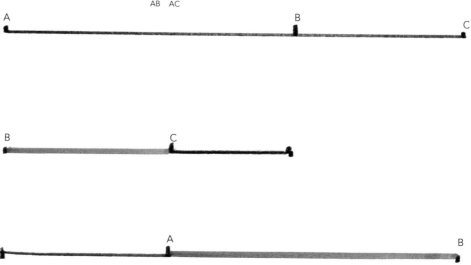

If possible place the vase below eye level (Fig. 2). Then you have more flowers, less vase; you also have a comfortable area of table for shadows and reflections to be visible. If the flowers in the vase have more overhang on one side or other, the placing of the vase needs to allow for it. If the overhang is considerable, a horizontal composition would be preferable (Fig. 3).

These are guidelines for a calm and comfortable composition. A different, equally valid, mood can be established when the flowers are allowed to explode exuberantly beyond the frame.

Another possibility is to stand back and place the flowers as part of an interior (see page 18, below). A further option is a close-up of a group of flowers, dispensing with the vase altogether (see page 19). It all depends on what the painter decides is the 'story'. Sketches like these help to make your purpose clear.

Tonal composition

A vital part of any painting is understanding the tonal values. It is the relationship of the lights and darks to each other that matters whether your style is delicate or bold. A quick way to see these values is to first shade your sketch all over, apart from the areas that are light or white. Then deepen the darker tones and establish where in the composition the darkest tone of all is to be placed. This need not take long and is a valuable way of foreseeing your painting.

Many experienced painters do preparatory sketches although some simply visualize them. Either way, a pause for reflection and digestion before painting helps towards painting that masterpiece.

Composition and drawing

Figure 1

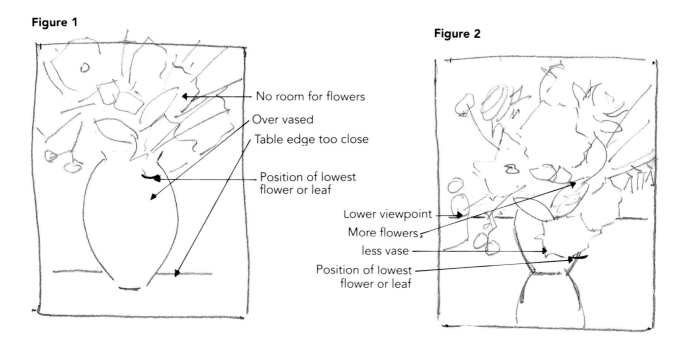

No room for flowers

Over vased

Table edge too close

Position of lowest
flower or leaf

Figure 2

Lower viewpoint

More flowers,

less vase

Position of lowest
flower or leaf

Figure 3

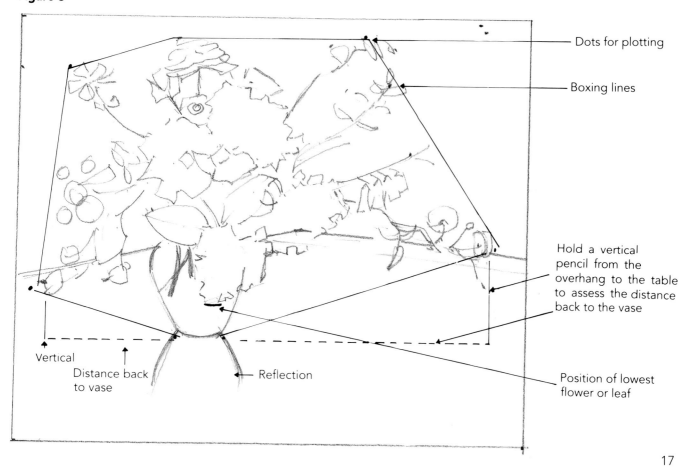

Dots for plotting

Boxing lines

Hold a vertical
pencil from the
overhang to the table
to assess the distance
back to the vase

Vertical

Distance back
to vase

Reflection

Position of lowest
flower or leaf

Tonal sketches

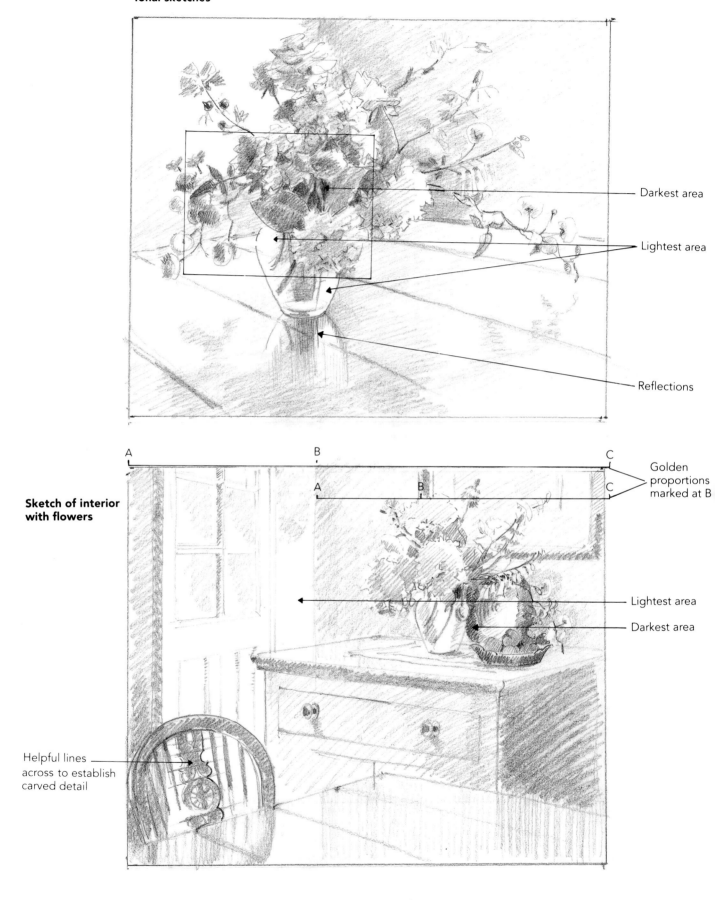

Darkest area

Lightest area

Reflections

A B C

Sketch of interior with flowers

Golden proportions marked at B

A B C

Lightest area

Darkest area

Helpful lines across to establish carved detail

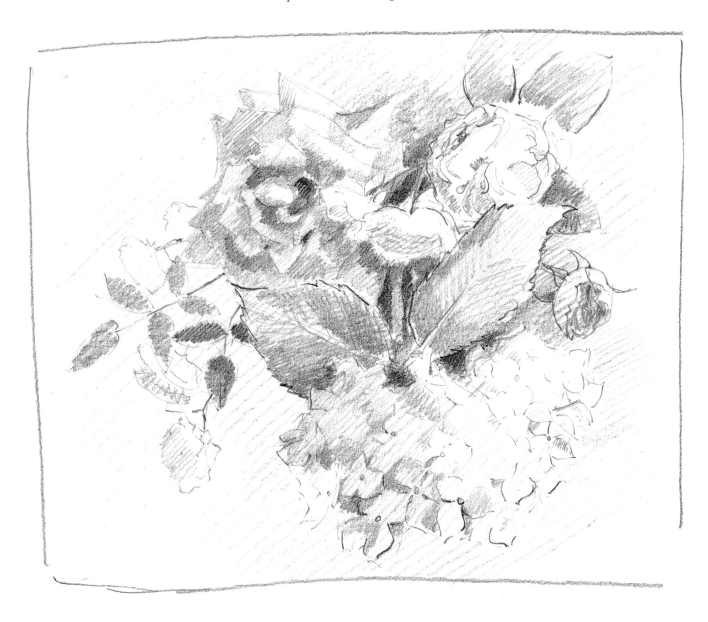

Boxing and plotting

Detail from tonal sketches, left

To create a composition made up of a number of small shapes such as flowers, I find it helpful to plot a series of dots to mark where the highest, lowest and widest flowers could go. These dots are then joined by lines which box the subject in, thus showing how the various elements could fit the paper. This approach saves working some beautiful detailed drawing only to find that it does not fit, and having to erase it. This is not only disappointing but spoils the surface of the paper.

The plotting and boxing method (see page 20) keeps lead pencil work to the minimum. It is very easy to adjust the plot at this stage. If you do need to erase, try rocking the eraser; this will remove most of a soft pencil mark. A 3b or 4b pencil with a good point is ideal to draw with – the soft pencil glides easily whereas if you use a harder lead any pressing would make indentations in the paper.

This illustration shows how a group of subjects can be understood as one shape in order to place it well on the page. Top left: the plan for **Mother's Day** *(page 80). Bottom right: the plan for* **The Orange Lily** *(page 77).*

The pansies showing awkward angles are solved by boxing first; likewise the daisy and poppy heads. The invasion shapes are the space shapes between the petals or group of heads, or the floor shapes between the bases of the pots. 'Seeing' these shapes and drawing them helps me keep the proportion of the whole subject in balance.

Plotting Boxing and Invasion Shapes

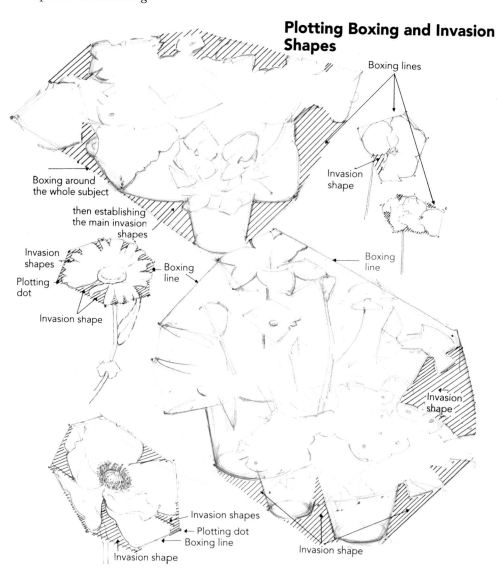

Boxing lines

Invasion shape

Boxing around the whole subject

then establishing the main invasion shapes

Invasion shapes

Plotting dot

Boxing line

Invasion shape

Boxing line

Invasion shape

Invasion shapes

Plotting dot

Boxing line

Invasion shape

Invasion shape

Once the plotting and boxing has been done, the major invasion shapes – the spaces between your petals, flowers or pots – can be established. Further details will then fall into place with ease. This approach is a great aid when dealing with flowers or leaves that offer difficult angles in perspective. All the plotting lines can be rocked out with a soft eraser prior to painting.

Leaves

I enjoy painting leaves. I enjoy studying their shapes and colours (see overleaf). Outdoors, they pick up a sheen from the sky or allow the light to glow through them. Only when they are in a vertical or near vertical plane do they show their own true colour, and even then their colour is affected by the pigment of the flower.

When I make the greens for a leaf I add a trace of the flower colour to the mixture. The need to do this sometimes is quite obvious, as in the rose leaves. The pigment also appears in the stems. Other times the blend is subtle as in the poppy leaves where the mauve pink added to the cool green will create just the grey green that is needed.

Plotting boxing and invasion shapes

Leaf diagrams

Plotting – a helpful guide to the layout of the composition. A few dots will enable you to see how it fits before doing any detailed drawing.
Boxing – an aid to understanding the overall shape and perspective of the leaves.

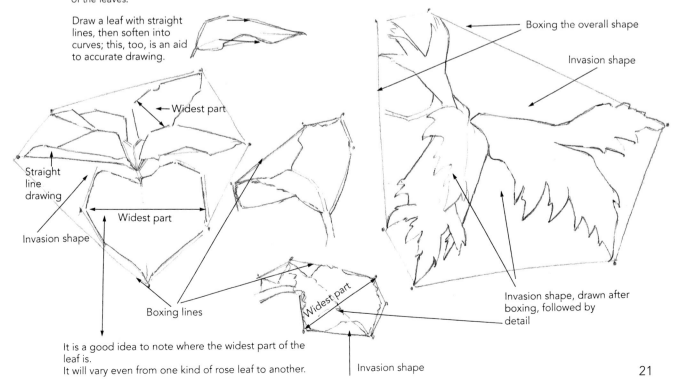

Draw a leaf with straight lines, then soften into curves; this, too, is an aid to accurate drawing.

Boxing the overall shape

Invasion shape

Widest part

Straight line drawing

Widest part

Invasion shape

Boxing lines

Widest part

Invasion shape

Invasion shape, drawn after boxing, followed by detail

It is a good idea to note where the widest part of the leaf is.
It will vary even from one kind of rose leaf to another.

21

Leaves

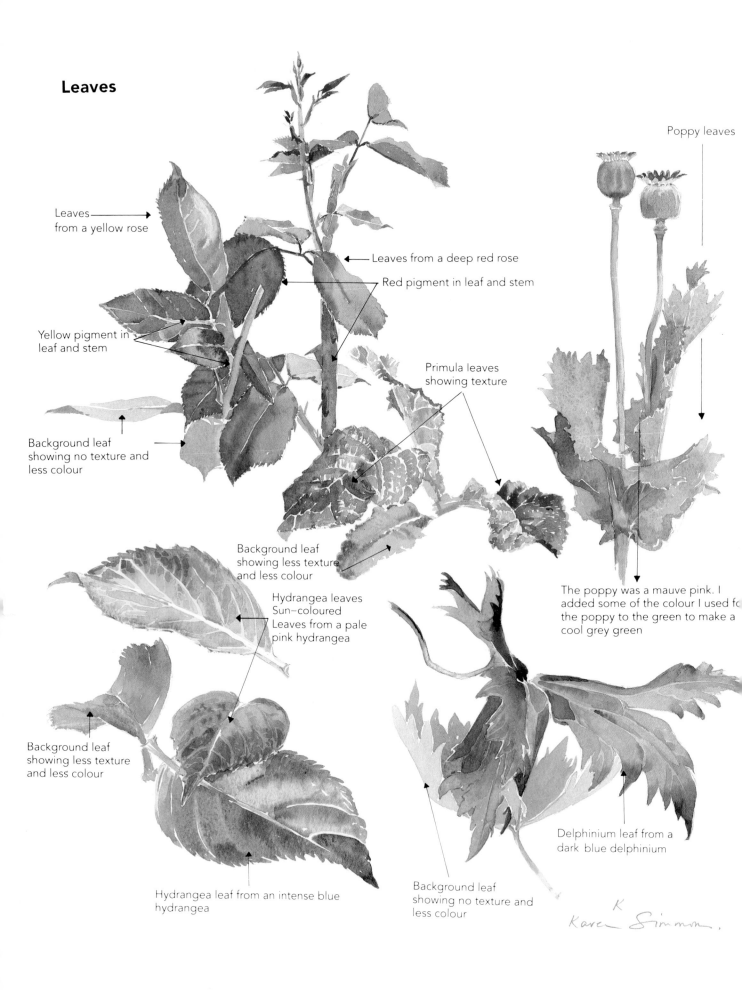

Leaves from a yellow rose

Poppy leaves

Leaves from a deep red rose

Red pigment in leaf and stem

Yellow pigment in leaf and stem

Primula leaves showing texture

Background leaf showing no texture and less colour

Background leaf showing less texture and less colour

The poppy was a mauve pink. I added some of the colour I used for the poppy to the green to make a cool grey green

Hydrangea leaves
Sun-coloured
Leaves from a pale pink hydrangea

Background leaf showing less texture and less colour

Hydrangea leaf from an intense blue hydrangea

Background leaf showing no texture and less colour

Delphinium leaf from a dark blue delphinium

Karen Simmon

Texture

When to texture a leaf and when not to is a hazardous area. Unless you are doing a botanical study it is best to limit the textured leaves to the focal area of the painting. Let the peripheral leaves have their rightful shape but leave the veining details out.

To test which part should be textured, hold your eye on the 'prima ballerina' of the painting. The leaves that are in focus show their details, but the leaves outside this area do not (see *Primroses*, page 53). It is inevitable that as we paint we move the eye from one item to the next, thus bringing each part into focus. If the subject is painted with this equal attention, the painting can look fussy and you lose sight of your 'prima ballerina'.

Stems and leaves

The angles of stems and leaves are an important part of the design of the flower and should be respected in your treatment of them. The stems for roses are often quite stocky and robust, appropriate to this tough survivor. To portray stems and leaves artistically finer than they are, or with droopy curves, is to deny the inherent character and design of the plant.

Painting outside directly from the subject, the angles are as nature intended them to be. If I need to cut and bring a flower inside in order to paint it, I place it in the flower separator (see page 7), in a glass dish, so that it can be seen at the same angle as outside.

Colours

The colours used on the leaves on page 22 are as follows:

Rose leaves Colours for the rose leaves were Cobalt Blue and Cadmium Yellow. Permanent Rose, Permanent Magenta and Cadmium Red were used for the pigmentation and were dropped in while the first colours were still wet.

Primulas The heavily textured primulas were scribbled with a weak solution of Cobalt Blue. The deeper richer greens were made with French Ultramarine Blue and Cadmium Yellow.

Poppies The poppies were painted with Cobalt Blue, Cerulean Blue and Cadmium Yellow Pale, and then a combinaton of Cobalt Blue and Permanent Rose was added, effectively greying the green.

Hydrangea leaves The sun-coloured hydrangea leaves were based with Gamboge, tinted at the edges with a bright green made from Cerulean Blue and Cadmium Yellow Pale. While still damp, Permanent Rose and Cadmium Red were added for the rosy blushes. The leaf from the intense blue hydrangea had some Cobalt Blue and French Ultramarine Blue mixed with a trace of Cadmium Yellow to make the darker blue tone for this leaf.

Delphinium leaf The same mixture was used for the delphinium leaf with a dilute Cobalt Blue representing the sky-related sheen.

Background leaves For the background leaves, a combination of Raw Umber with Cobalt Blue was used to convey the cold and warm surfaces. By reducing both the texture and colour value of the leaves they could recede, playing a supportive role.

Silhouette of a Snapdragon
(18½ x 14½in, 47 x 37cm)
A quick and delightful way of understanding the profile and structure of a flower or plant is to paint or draw a silhouette. Leaves and flowers may overlap, creating new shapes and space shapes. I sometimes use a silhouette of a plant or flower in the background of a subject to indicate more flowers without robbing the main ones of interest.
Colours used: *Permanent Rose, Burnt Sienna and French Ultramarine Blue.*
Paper: *Bockingford 140lb/300gsm.*

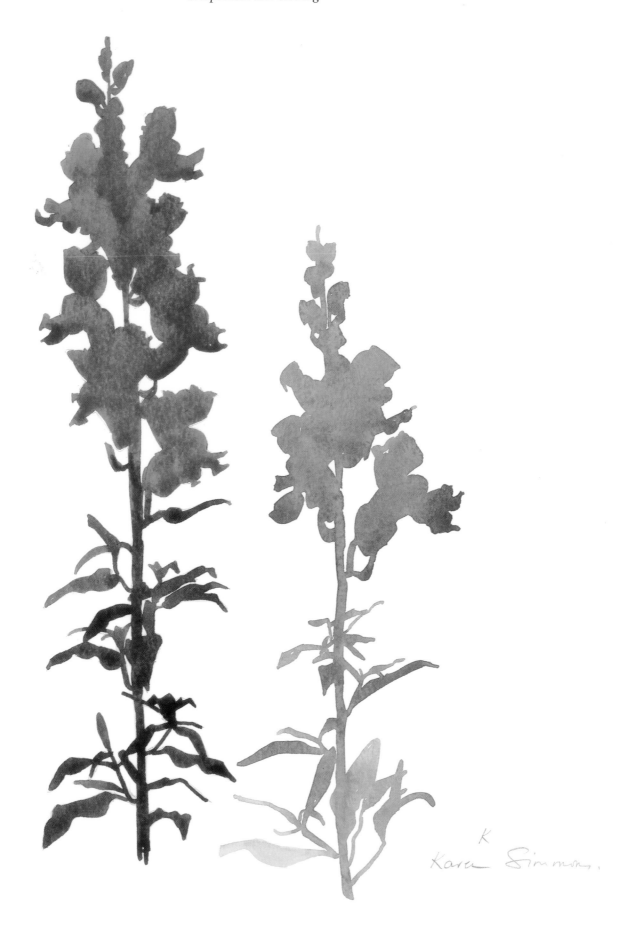

Kara Simmon

Whites, yellows, pinks, reds and blues

Choosing the right shadow mixture for the variety of colours in flowers is one of the major hazards of painting this tantalizing subject. The following examples show you some of the solutions that I have found helpful.

Whites

I love white flowers and could have filled the whole book with them. There is a gracious peace to them in the house, but in the garden or in the wild they light up and enhance their surroundings. At dusk they appear luminous and some reserve their fragrance for this time of day.

In pure watercolour the white is represented by leaving the paper untouched. To paint white flowers on white paper one is dependant on the shadow colours – the leaves, the stems and the backgrounds – to show them up. It is not always necessary to have a dark background to show up a white or pale flower – a tone and colour that gives sufficient contrast suffices. Too dark a background can rob a painting of air and depth. The shadows on a white flower need to be painted with great restraint. The more grooves and details that are painted in, the less white the flower gradually becomes.

To sacrifice some of the observed texture on the lightest areas, try leaving the paper blank. This restraint will give more power to the white. If you half close your eyes, you lose some of the texture and need paint only the more pronounced flutes and grooves. So don't 'tread in the snow!'

The colours needed for the shadows on a white flower depend on what is around. Sometimes the shadows are blue, other times creamy yellow, pale green or the faintest mauve.

Lilies

These lilies were standing tall against a white wall. I drew them using the boxing approach, taking great care to place the heights of the buds in relationship to each other. Once I had drawn in the petals, I erased the boxing lines by rocking the eraser; this lifts off the lead without roughing the paper.

Lilies
(20 x 16in, 51 x 41cm)
OPPOSITE This subject caught my eye. The lilies were beginning to open and were casting their distorted shadows on to the white wall – there are so many colours in a white flower! Observing them well helps to describe the form and curve of each petal. It is essential to keep some white unbroken. (I didn't notice the little ladybird sitting on the bud until after I had started painting!)
Colours used: *Cobalt Blue, French Ultramarine Blue, Permanent Rose and Gamboge.*
Paper: *Bockingford 140lb/300gsm*

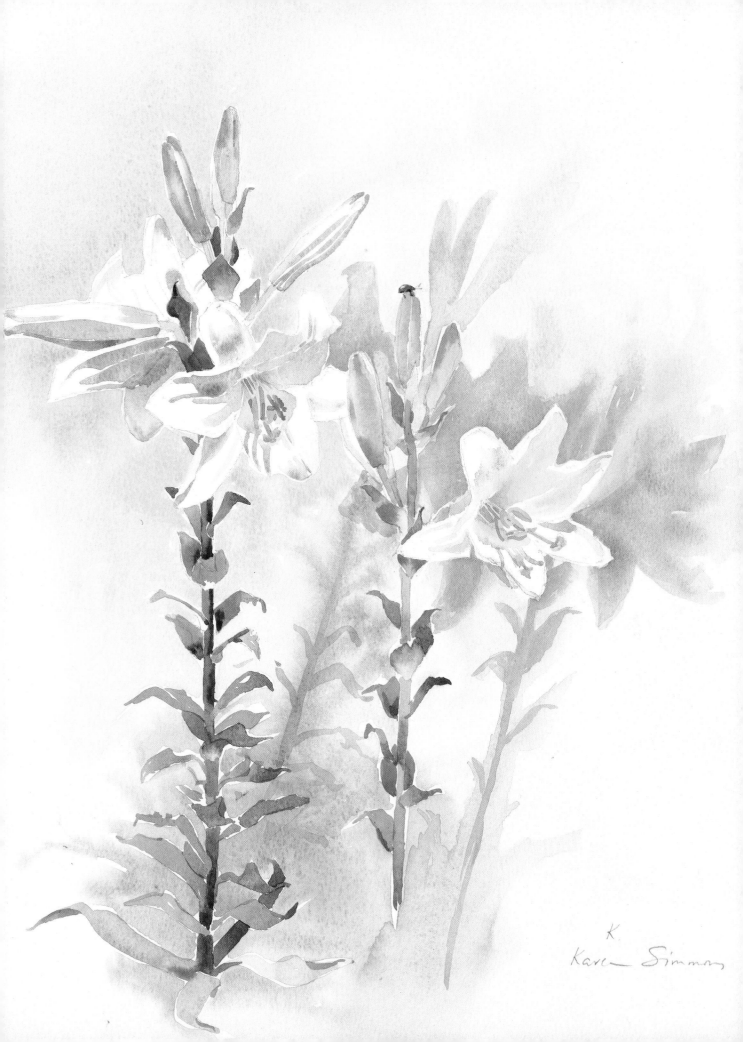

The petals that turned away from the centre were shadowed by blue. Wetting the shadow shape and then dropping in the colour worked best and gave a softer effect. The light filtering through the lily combined with the reflected colour from the yellow stamens to give a real glow to the heart of the flower. Some petals reflected the green from nearby buds. However, the facets on the buds were much crisper, each facet reflecting a subtle difference of colour.

The colours I used were Cobalt Blue, sometimes mixed with a very little Permanent Rose making a mauve. Adding a touch of the yellow muted the colour to near grey. The yellow was Gamboge and when mixed with a little Cobalt gave me the light green I needed for some of the petals and buds. The leaves were also painted with Cobalt Blue and Gamboge, varying the amount of blue and yellow. I deepened the tone with French Ultramarine Blue and occasionally greyed the green by adding in a little Permanent Rose. The stem was painted with a richer mixture of Permanent Rose. The little ladybird appeared and sat on the top of a bud, so I painted her in too.

What had attracted me to the subject were the shadows cast by the lilies on the wall. To achieve a soft shadow I wet the whole paper from around the flower heads and leaves out to the edge of the paper. I made sure it was shiny wet. I dropped some Gamboge into the wet and let it disperse. As the shine left the paper but while the yellow was still damp, I quickly painted the thrown shadows.

For the mauve shadow colour I used Cobalt Blue with Permanent Rose, muted with a little yellow. As the paper dried, the shadow shapes needed sharpening towards the stems.

I then re-wet the lower half of the paper – from the leaves to the edge of the paper – and dropped some green into this area.

As long as the wet area is well ahead of the colour, the colour has room to expand in the wet back to nothing. This way you can blush in a background without any trouble

Spring Whites

Spring Whites

(20 x 16in, 51 x 41cm)
OPPOSITE It was too cold to work outdoors, so I gathered a few narcissi, white daffodils and a twig or two of wild cherry blossom. I flung these into a wide-necked jar, letting them fall as they would. The lack of contrast invited the challenge.
Colours used: *Aureolin, Gamboge, Cadmium Yellow, Rowney Raw Umber, Cobalt Blue, Permanent Rose, Cadmium Red, Light Red and Madder Brown.*
Paper: *Bockingford 140lb/300gsm.*

The pure innocence of the narcissi and the white daffodils was very appealing as were the glossy pleats of the young leaves of the wild cherry. I hardly used any pencil work in preparation for this subject, only plotting in the main heights and angles. The visible pencil marks are from some over-drawing on the wild cherry blossoms which was done last. The more drawing practice you have, the more you can draw mentally – rather like mental arithmetic!

For the main daffodil I painted the trumpet area first, using Aureolin and a very dilute Raw Umber deepened with a trace of Gamboge. Aureolin is a beautiful transparent yellow with a greenish tinge; together with Raw Umber it gives a luminous lime green.

I mixed Cobalt Blue and a little Permanent Rose to make a blue mauve, which could be further muted by adding in a tiny amount of the yellow. This makes a lovely luminous grey very suitable for some of the shadows on white and on a pale

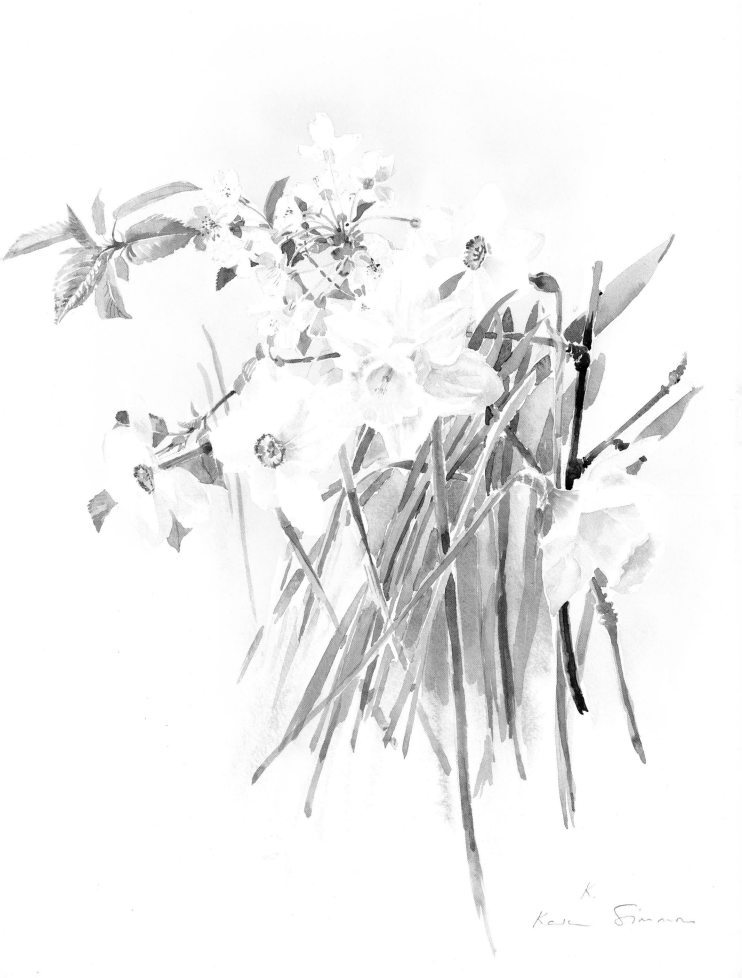

yellow flower, and I used the blue mauve to deepen the tone on the turn back frill of the trumpet, leaving both the outer and inner edges white.

To achieve a soft edge to this detail I dampened the frill and deepened the tone in the middle, allowing the pigment to creep back gently to white again. If a crisper shadow is needed, the neighbouring areas should be dry.

I tackled the petals one by one, using warm and cold mixes of the shadows and deepening the tone on the trumpet facet and the shadowed petal. Then I painted the interior of the trumpet with Gamboge diluted with Raw Umber.

I painted the narcissi the same way, noting where the shadows were warm and where cool. I ignored many of the grooves and shadows in order to maintain the pure sparkling white. The centres were painted with Gamboge, and Cadmium Red was used to deepen the colour in places.

The stems are faceted, and were painted with a light cool blue, deepened on the shadow facet with a deeper tone. Occasionally I used a richer warmer green. Where the stems or leaves came behind a flower they provided a welcome chance to show up the white petals and the white cherry blossoms, their smaller flowers with spangled centres and fine stems made a pleasant foil for the bigger heads.

The newly unfurled leaves of the cherry blossoms were beautiful. I blended Light Red with a yellow green for these fine pleats, making the yellow green with Cadmium Yellow and a little Cobalt Blue. I let the colours bleed together, preserving a little of the white paper to represent the sheen and pleats. The bolder woody twigs were added creating a contrast, and I used Raw Umber deepened with Madder Brown.

Lastly I added the background by wetting the paper, going carefully around the subject and taking the water all the way to the edge of the paper. With the paper shiny wet I dropped in some yellow close to the flowers. Then, putting the brush down, I tipped the paper to allow the colour to travel outwards. I used the same process among the stems but dropped in some cooler greens, again allowing the pigment to travel. As the paper was wet to the edge, the colour could disperse to nothing.

White Camellias

The crisp white camellias opposite, with their scrambled yellow centres showed up enticingly against the shiny dark leaves. I placed a few twigs in the flower separator in the glass dish so that the stems were at their natural angles. Camellias come early in the year when it is too cold to work outdoors. Instead I set them up in my conservatory so that the down light would be as natural as possible. It was not necessary to paint the dish.

The big camellia head was a delight. The creamy yellow centre of shredded curly petals was surrounded by bigger ones, crisply white as a starched collar. I painted the centres with dilute Gamboge first; a more concentrated Gamboge was added while the pale yellow was still wet. When this was dry, I emphasized one or two edges by indicating the golden shadows underneath. I used both cool and warm greys where the bigger flat petals were in shadow. For the cool grey, the mixture

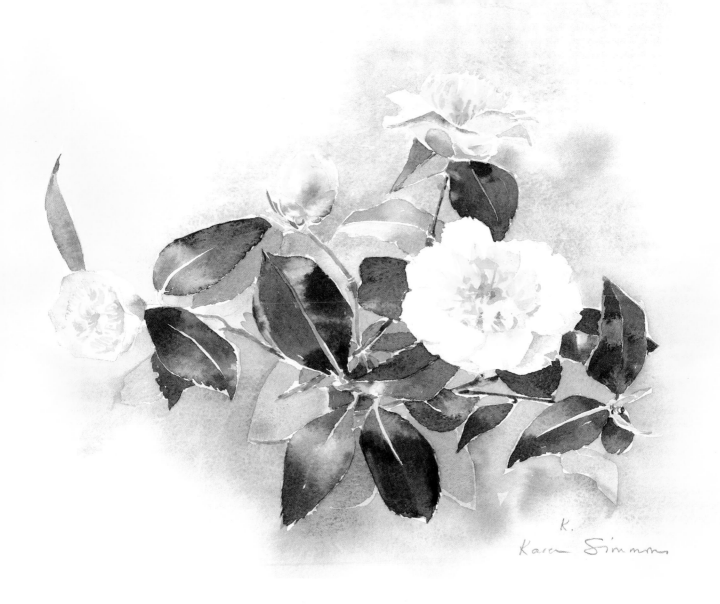

was Cobalt Blue, Permanent Rose and just a touch of yellow; for the warm grey, the yellow was increased. Both colours were kept well diluted. Where the light was strong the individual petal markings were ignored in order to maintain the dazzling white.

The top camellia had a very strong tone on the foreward edge. I saw this as a strong blue mauve bleeding back into the yellow on the underside of the head. The strong yellow of the centre made a bright contrast which further enhanced the plain white of the camellia below. The bud was round and pearly with reflected lights, some cold (blue), some warm (yellow).

The deepest tone was a warm Raw Umber. The partly opened camellia was still encased in its cup of petals, the centre nestling in shadow. The shadow colour reflected the yellow at heart, only the outer rim showed cool.

Camellia leaves are dark, smooth and glossy. To convey the shine you must observe where the curve of the leaf picks up the sheen of the down light. So I painted the pale blue first using dilute Cobalt Blue. Then I mixed Cobalt Blue with Cadmium Yellow and added this either side of the light blue for the richer green. A stronger mixture still was needed for the darker green, so I used French Ultramarine Blue and Cadmium Yellow. This combination was fairly concentrated

White Camellias
(14 x 17½in, 35.5 x 44cm)
The strong contrast of the glossy green leaves shows the glowing yellow and white heads to great advantage. The way the curly centres are domed above the flat collar of crisp white petals is an invitation to paint.
Colours used: *Gamboge, Cadmium Yellow, Raw Umber, Cobalt Blue, French Ultramarine Blue and Permanent Rose.*
Paper: *Bockingford 140lb/300gsm.*

and was added while the previous colour was still damp. The various greens and tones describe the shape of the leaf. The background was added as before. I wet the whole paper with clean water using a big brush with a good point. To achieve the effect of the serrated curly petals of the top camellia I invaded the shapes with the tip of the wet brush so that when I dropped the colour in it would follow down the prepared wet marks. I used a blend of Cobalt Blue with a trace of Permanent Rose. Lower down the page I added in some yellow and then some blue green, letting the colours fuse and disperse on their own. When this had dried I re-wet the foreground but left some leaf shapes dry, then dropped in some more blue green. This cut out some more leaf shapes from the undercolour.

Yellows

Yellow flowers, both pale and deep, are notoriously difficult to paint. It is helpful to trap some white near the yellow, for the white and yellow enhance each other. As a white flower is flattered by a touch of yellow, so a yellow flower needs the sparkle of white. This is an example of artistic licence where it is necessary to tell a lie to tell a whole truth.

The main hazard, however, lies in choosing the right shadow colour. So often a painting which has been going well becomes an 'Oh dear!' when the shadows are applied. Purple is the opposite colour to yellow, so it is in the mauves that you seek a colour for some of the shadows.

I make a mauve by combining Cobalt Blue or Cerulean Blue, even Prussian Blue, with Permanent Rose or Permanent Magenta. With these colours you can make a delicate blue mauve suitable for the palest yellow flower which, when glazed over the yellow, mutes it to a luminous grey. When a pinker mauve is mixed and combined with a richer yellow, it becomes a wonderful bronze colour which is not too heavy.

Sand Poppies

I prepared for this painting opposite by plotting and boxing the poppy heads. I then drew in the stems which provided a rhythm to the whole, and planned some of the leaves.

One flower head and three petals were isolated and kept dry while I wet the whole sheet of paper. I then dropped in the Aureolin, letting it run and disperse, and then added in some Cobalt Blue further down letting the two blend together. I put a wet cotton cloth under the watercolour paper, clamping both firmly to the light canvas board. This technique is a tremendous help in the hot sun as the moisture evaporates and thus allows the paint to 'pool' for longer.

When this first blush wash had dried I tackled the 'prima ballerina' poppy which I had left dry and white. To capture the fragile crimped petals I used a brush which

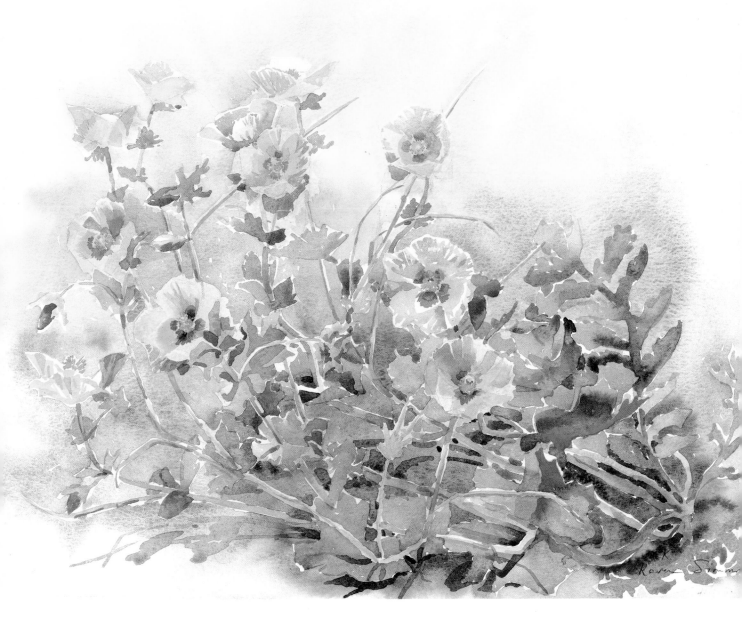

came to a good point and, with clean water, prepared a few of the pleats. Into this I dropped the blue mauve and, towards the centre, some touches of Aureolin and Gamboge.

I kept the forward petals almost untextured as these were catching the light – a pale Aureolin wash sufficed for this. The dark centre markings were added last, using Madder Brown with a touch of Cobalt Blue. Other poppy heads were painted as simply as possible, showing texture only where essential, and the cups that caught or cast shadows were observed by using Gamboge enriched with Permanent Rose. Next I painted the light green stems and the grey blue wrap-around leaves.

For the background it was necessary to re-wet section by section, dropping in first a deeper yellow (implying more poppies) and then, gradually, some mauve to

Sand Poppies

(15½ x 19in, 39.5 x 48cm)

I espied these sand poppies in Greece and loved the contrasts of colour. While I painted, a snake rustled by; I threw my water at it and it wriggled away.
Colours used: *Aureolin, Cadmium Yellow, Gamboge, Yellow Ochre, Madder Brown, Permanent Rose, Cobalt Blue and French Ultramarine Blue.*
Paper: *Bockingford 140lb/300gsm.*

reddish purple. Afterwards I darkened the cast shadows on the ground and the shadows on stems and leaves.

I was exhausted from concentration and the hot sun, so I packed up and went for a swim.

Sunflowers

I placed the big sunflower opposite against the light and let the light fall on the one behind. This enabled me to use strong colours for the bigger head. I plotted the composition with very little pencil work, then, isolating some white petals on both heads, I wet the whole paper generously. I blushed in some Aureolin, the deeper Gamboge where the big head would be, and some Cobalt Blue, gradually adding the green made with Cobalt Blue and dilute Gamboge.

I quickly painted in some ragged petals while the paper was still damp so that they would have soft edges. As the painting dried, I added the crisper shapes. Some petals were painted with pure Gamboge, and some with Gamboge and Permanent Magenta. For other darker ones I used Gamboge, Permanent Magenta and French Ultramarine Blue – Gamboge and Permanent Magenta combine to make a hot bronze colour which is very rich.

As I painted the petals, I was careful to observe the space shapes between. I re-dampened the centre and painted the irregular rim and middle with the light and dark tones to indicate the volume and shape. Lastly I suggested the spiral pattern with Madder Brown.

I needed all three blues for the leaves and stems for different reasons. For maximum texture, I used French Ultramarine Blue with a little Gamboge or Cadmium Yellow and for a brighter fresher green I used Cerulean which also granulates heavily suggesting texture. In places where the light caught a leaf facet I used Cobalt Blue.

The sunflowers were a total contrast to the delicate sand poppies. Different again, and just as challenging, were the daffodils.

Sunflowers

(20 x 16in, 51 x 41cm)
OPPOSITE The massive sunflower was a real thumper. It towered above my head. Did I really want to paint it? So many artists have gone before: Van Gogh, of course, and Emil Nolde both achieved the impossible.
Colours used: *Aureolin, Cadmium Yellow, Gamboge, Permanent Magenta, Madder Brown, Cerulean Blue, Cobalt Blue and French Ultramarine Blue.*
Paper: *Bockingford 140lb/300gsm.*

Daffodils

I planned and drew the daffodil heads (see page 36) with a 4b pencil which had a really sharp point. The unexpected space shapes helped to maintain the accuracy of the drawing and to put petals in perspective.

I kept several petals white and dry while I wet the whole paper, blushing in the yellows, the blues and the greens. When this was dry, I painted dilute Aureolin on some of the petals, keeping plenty of white showing where the light was brightest.

Mixing a suitable shadow colour for the light yellow petals is a major hazard when painting daffodils. From trial and many errors I have found the following to work: Cobalt Blue with a little Permanent Rose makes a blue violet which when painted over yellow converts to a soft grey. With less Permanent Rose the grey will

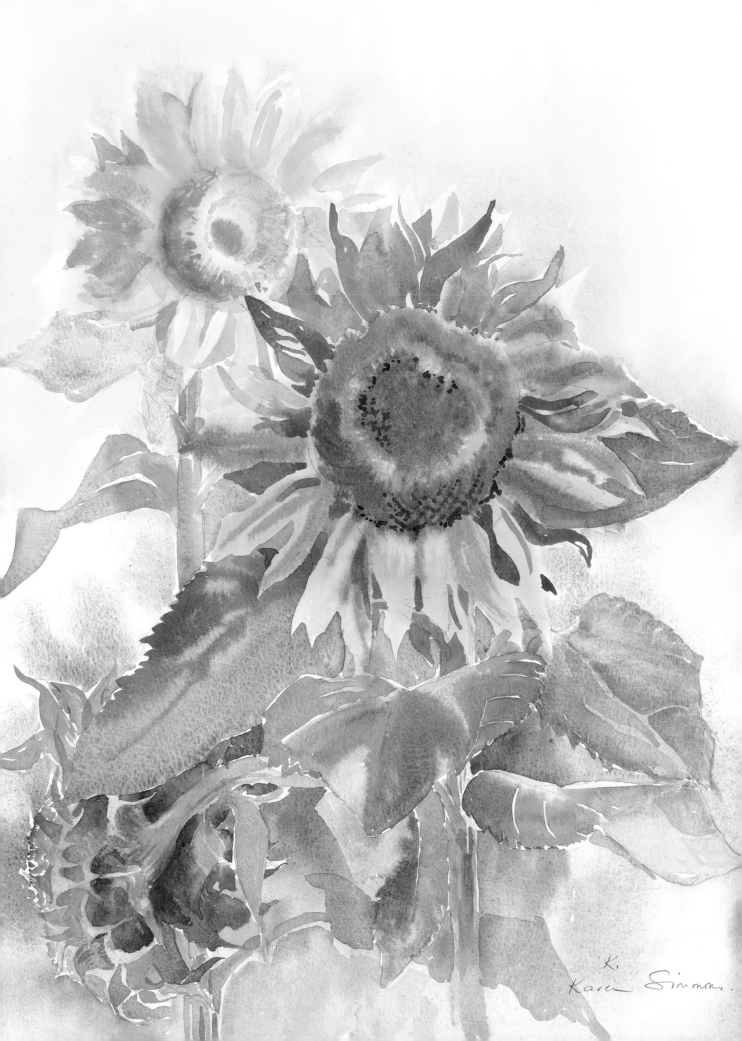

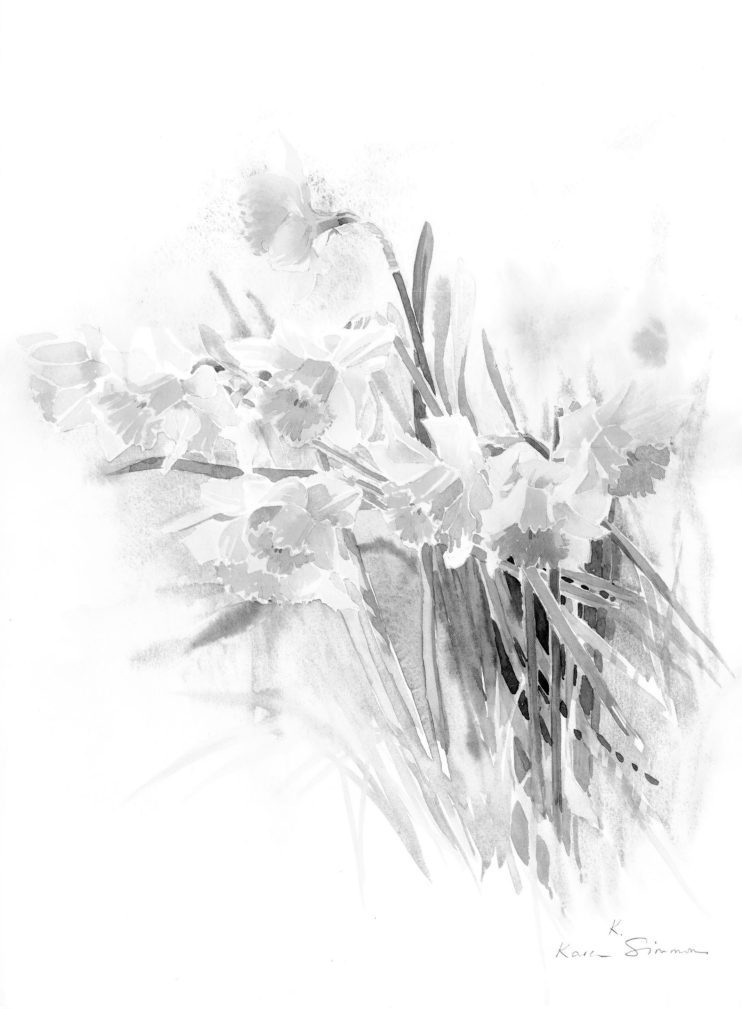

have a slightly greenish tinge. This indeed is often there, so increase the Permanent Rose and you have a red violet which is ideal for the warmer shadows.

The deeper trumpets were shadowed with Gamboge, Permanent Rose and a little Cobalt Blue. Quite a few of the pale yellow petals emerged from that first yellow blush. Where I needed some more contrast, I re-wet the background and added in more of the blues and greens, and while it was still damp I suggested some of the leaves. When the paper was dry, I added more leaves and sharpened the tone where required. By re-wetting above the heads I was able to suggest a few more out-of- focus daffodils. Using leaves and flowers out of focus in this way adds depth and volume to the subject without robbing the main flowers of their attention. Daffodils remain the most elusive flowers to capture.

Pinks

Pinks ranging from the most delicate to the most vibrant are found in a multitude of flowers. The 'right' shadow colour makes all the difference to the painting. The paler the pink, the more reflective it will be of its surroundings. Where the light falls, the cooler pink might be observed. As the flower turns its petals away from the centre, the shadow colour reflects the colours nearby, and where the light comes through the petals you see a warmer pink.

Shadowing a pink flower with red makes the subject glow; shadowing a pink flower with mauve without looking may lead to a rather disappointing result: the flower may give the appearance of being about to die! Another aspect of having both cool and warm pinks present in the painting is that a clash of colours is allowed for, and this makes the painting more vibrant.

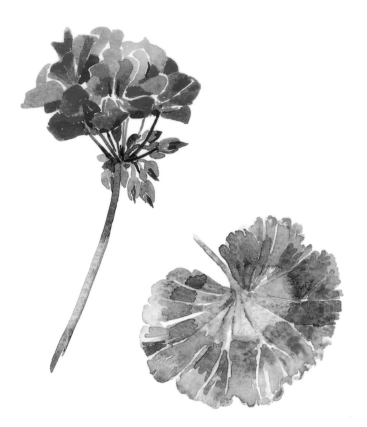

Daffodils
(20 x 16in, 51 x 41cm)
OPPOSITE *A bright Spring day and bright yellow daffodils are reason enough to bring out the paint brush. This group was in my garden underneath some apple trees. I sat on the ground on a dustbin bag to paint them. I painted* **Meadow Daffodils** *(see page 51) in the same spot.*
Colours used: *Aureolin, Cadmium Yellow pale, Cadmium Yellow, Gamboge, Permanent Rose, Cobalt Blue, Cerulean Blue and French Ultramarine Blue.*
Paper: *Bockingford 140lb/300gsm.*

Geranium with Leaf
(9½ x 8½in, 24 x 21.5cm)
Nature herself, or the breeders, designed this geranium with an in-built clash of colours! The vertical petals show an orange red which is amplified by the light coming through them. The flatter sky-facing petals show the cooler strong pink, and the shadows underneath are a rich warm red. The leaf has a distinctive shape, and red pigment stains its pattern. The pigment of most flowers is found in the stems and leaves.
Colours used: *Permanent Rose, Gamboge, Cadmium Red, Cerulean and French Ultramarine Blue.*
Paper: *Bockingford 140lb/300gsm.*

Rhododendron Loderi

Rhododendron Loderi

(16 x 20in, 41 x 51cm)

*This rhododendron, also known
as the King George, is highly scented,
and exceptionally beautiful.*

Colours used: *Permanent Rose,
Permanent Magenta, Gamboge,
Cadmium Yellow, Cobalt, Cerulean
and French Ultramarine Blue and
Madder Brown.*

Paper: *Bockingford 140lb/300gsm.*

I plotted the two party-frocked heads and the curving stem, and drew the individual flower heads and, where they were visible, the leaves (below). I painted each flower separately, although using similar methods each time.

Using a brush with a good point and plenty of water, I prepared the way by wetting all the areas except those where the light fell. This part I kept dry as here the colour was bleached out. Into the rest I blushed in a dilute Permanent Rose: the front petal curved upwards picking up sky-related blue shadows strongest on the curve. I dropped Cobalt Blue on the curve, letting it disperse back to white again. While the paper was still damp but not yet dry I returned with a denser mixture to deepen the tone.

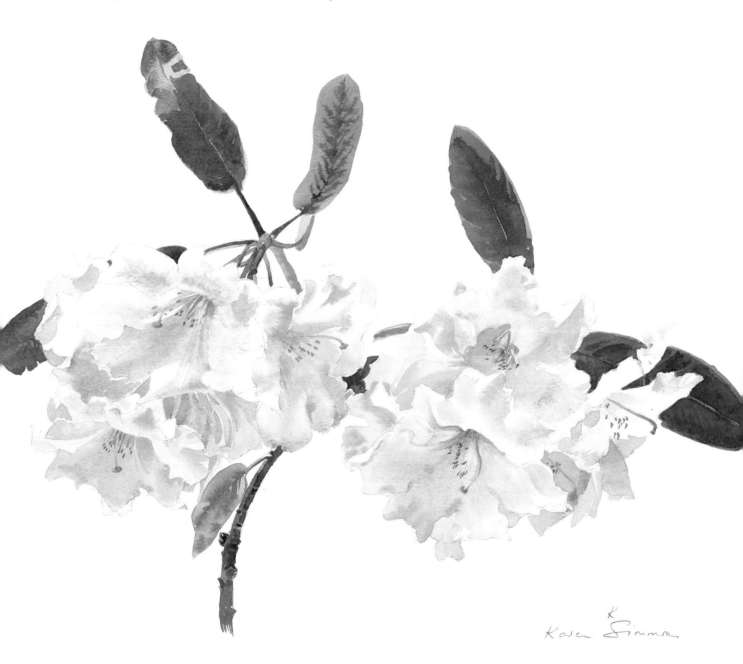

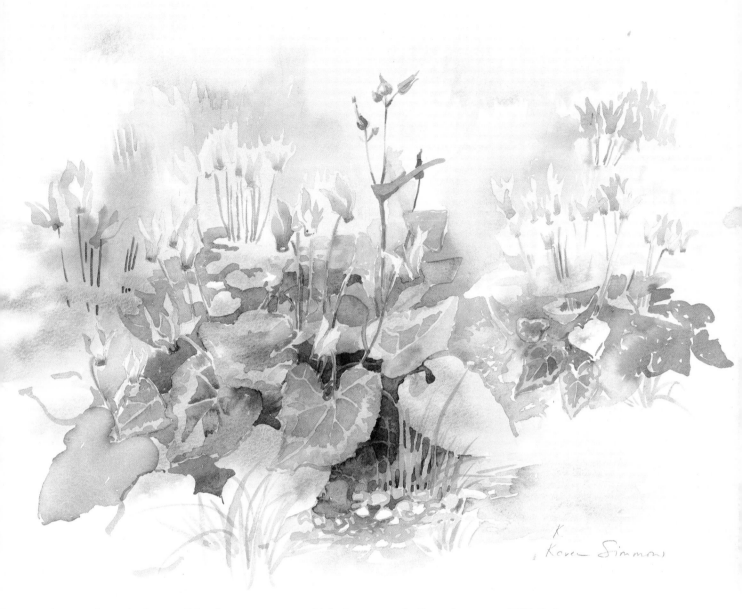

Flowing from the heart of the flowers came a gold fusing to coral, dispersing to a pale mauve. Gamboge bled into Permanent Rose, which in turn bled into Cobalt Blue, conveying the subtle shades in the petals. I needed a deeper coral in places and I made this with a denser mix of Gamboge and Permanent Rose. The cool pinks, blues and coral colours clashed gently, keeping the colours bright and fresh.

The leaf at the top had a foundation of Cerulean Blue, the others a foundation of Gamboge. The deeper green was painted over this using French Ultramarine Blue combined with either Gamboge or Cadmium Yellow. The deeper green was first added while the undercolour was still damp. As it dried, the occasional vein could be left to show through. A glowing focal point to the painting came where the yellow leaf was neighbour to the coral pink petal.

The stem was first painted with some of the Gamboge, then tinted with Permanent Rose. The detailed markings and darker accents were painted last with Madder Brown.

Wild Cyclamen
(16 x 19½in, 41 x 49.5cm)
This breathtaking sward of wild cyclamen was sighted in a derelict garden in North Cyprus. Sheltered by stone walls, it massed to a beautiful pink carpet. The friendly owner of the garden came up to see what I was doing and bent and pulled up the very weed I was about to paint!
Colours used: *Permanent Rose, Cobalt Blue, Cerulean Blue, Cadmium Yellow and Raw Umber.*
Paper: *Bockingford 140lb/300gsm.*

39

Reds

Each colour has its challenge and the reds have theirs. To achieve the same vibrancy in paint as nature does in her flowers is difficult. The only way is to neighbour different reds, to set up a clash of colours which conveys extra power to the colour. Do I deceive? Yes, I do. It is better to tell the whole truth: yet if you observe closely, the light bleaches and cools a petal, producing the opportunity to use Permanent Rose. If light comes through a petal with an orange glow, Gamboge with Cadmium Red can be used and you have a clash.

Nature, too, marks her flowers with clashing colours as in the *Red Snapdragon* (page 43). To get a really bright red I undercoat the area with yellow, possibly a Gamboge Yellow, then overlay this with Cadmium Red. Cadmium Red painted on to white paper will dry a disappointing red – the colour lets a certain amount of white paper show through which weakens the red – but with an undercoat of yellow the red dries with a real glowing impact. Sometimes I do wet into wet; other times I let the yellow dry first, then overlay it with the Cadmium Red.

To achieve a really dark red I have tried various combinations: Permanent Rose together with Cadmium Red in a dense mix make a lovely medium dark. Crimson Alizarin looks good with its rich ruby red while wet, but in my view dries disappointingly, looking dull and heavy.

I have used Permanent Rose, Cadmium Red with Olive Green to make a really dark red that dries true, and Permanent Magenta with Cadmium Red also stays true and rich. Darkening a red with a blue will give you the dark tone, but also the impression that the flower is dying.

Red Camellias

On the full facing camellia opposite I wet the lighter petals, blushing in some Permanent Rose. As the wet lost its sheen I added some Gamboge Yellow. I deepened the colour where needed with Cadmium Red, and darkened still further with Cadmium Red combined with Permanent Rose.

By half-closing my eyes, I could identify the tones of the camellia head. I kept the lighter part extra light so that the darker part could have more contrast, and painted the centre petals individually, keeping the tiny white intervals to suggest the upstanding crispness of the petals.

Some white stripes were also left on the forward patterned petal. The head was seen against the light, presenting a really dark view of the cupped petals on the underside. The light was penetrating through the petals showing around the edge. For this I made a coral orange with Gamboge and Permanent Rose. For the dark red I mixed Permanent Magenta with Cadmium Red with a trace of olive green added where the tone was darker still. I needed olive green with a trace of red for the greens on the underside.

The bud had a lovely silky sheen picking up a highlight, and for this I used a dilute Permanent Rose deepening it with Cadmium Red bronzed with a little

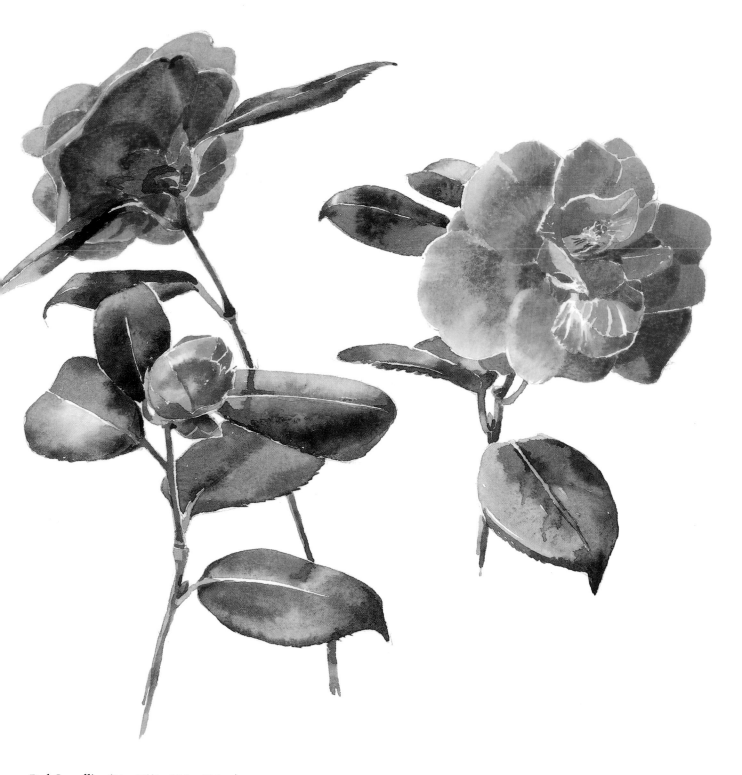

Red Camellias *(14 x 17½in, 35.5 x 44.5cm)*
To achieve the vibrancy of the petals, I clashed the reds from cool – Permanent Rose – to warm –
Gamboge with Cadmium Red using both light (more water) and dark versions (less water), then
darkened still further with Permanent Magenta and Cadmium Red.
Colours used: *Permanent Rose, Gamboge, Cadmium Red, Permanent Magenta, Madder Brown,*
Cobalt Blue and French Ultramarine Blue.
Paper: *Bockingford 140lb/300gsm.*

green. The bud cup, with its papery appearance, was painted with Yellow Ochre.

I was impatient to start on the leaves. They had such a gloss that they reflected the colours around them. Near the dark head I noticed that there were red reflections on the leaves. Many leaves presented a flat angle to the sky and had a blue sheen where the light fell on them. To achieve this effect I undercoated the leaves with Cobalt Blue. While this was still damp I added a richer green where necessary, using Gamboge and French Ultramarine, and then added still more French Ultramarine and a trace of Cadmium Red to make a true dark. The stems were painted first with a yellow Gamboge-based Green and darkened with Madder Brown.

Red Snapdragon

I drew the snapdragon opposite with a minimum of pencil work, but took care with the space shapes that are such an important part of the overall design. I started at the top, leaving the green buds till later and treated each head separately. For the pink I used Permanent Rose, for the mauve pink I added some Cobalt Blue to the Permanent Rose. The shafts were coloured with Permanent Rose and a touch of French Ultramarine Blue darkened further with Permanent Magenta and French Ultramarine Blue. This combination made a magnificent royal purple.

The centres were orange and red. The rich Gamboge Yellow with Cadmium Red seemed the right mixture for these thrusting lips. The hats and petals that caught the light were painted with Permanent Rose, Cadmium Red being added to deepen the tone. For the dark reds I used Permanent Magenta with Cadmium Red. The neighbouring snapdragon was painted with a warmer and weaker mix of the same colours. For the silhouette behind, which suggests another spear, I used a Cobalt Blue with Permanent Rose, muted with a trace of green.

The leaves were a tangle, but by taking care with a few, I could suggest the rest with looser strokes. Cobalt Blue, French Ultramarine Blue and Gamboge were the colours I used for the various greens. Where the leaves had a duller grey look, I added some of the red into the mixture.

I put the background in afterwards. I tilted the board flat, and used lots of clean water to wet carefully from the subject out to the edge of the paper. I dropped the chosen colour close to the subject, and then put my brush down, picked the board up and tilted the pigment away to disperse to nothing as it reached the outer edge.

Because it is difficult to manage the whole background at one wetting I make sure there is always plenty of wet paper ahead of the colour. By dropping the colour well behind the wet area, the colour can disperse before hitting a dry edge. Then I can re-wet the paper for the next section, carrying on as before and creating no join marks. The colour that is dropped in needs to be quite strong as there is a lot of water there already. To drop too dilute a mixture in just floods the colour away. This technique does require a little practice but once you have mastered it you will find putting a background in a delight rather than a nightmare.

The colours in the background of the snapdragons were colours I had used in the painting, giving the illusion that there were more flowers beyond. Likewise I gradually bled in some greens which suggested more leaves.

Red Snapdragon

(18½ x 14½in, 47 x 37cm)

OPPOSITE Nature did the clashing for me on these snapdragons! They appeared so vivid in the flower bed and, on close inspection, I saw that they showed every conceivable red. The shafts were purple, the centre lips orange, the hats where the light caught them pink, and the darks the most dramatic rich velvet red.

Colours used: *Permanent Rose, Permanent Magenta, Cadmium Red, Gamboge, Cobalt Blue and French Ultramarine Blue.*

Paper: *Bockingford 140lb/300gsm.*

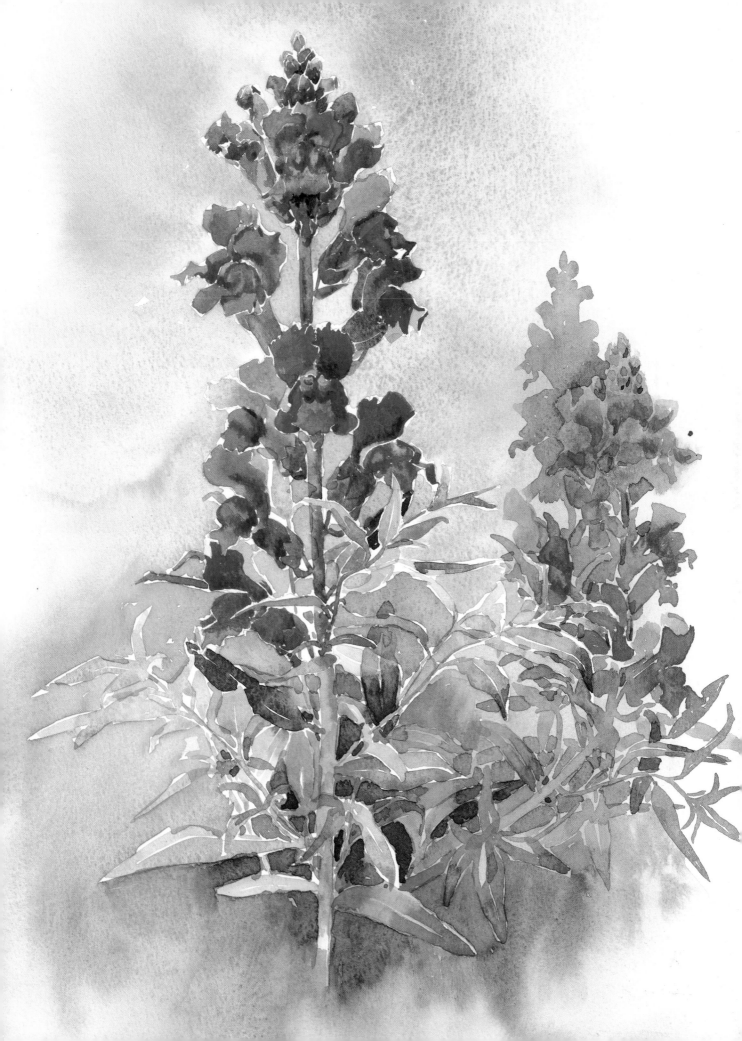

Blues

As with the reds, the flowers that look blue are often made up of a variety of blues, purples and pinks; it is this mix which gives the blue such carrying power. The most vivid example is the bluebell. Even the humble forget-me-not has florets at different stages of development on one stalk. The combination of pinks and various blues makes the colour seem stronger than each separate floret would warrant. To mix the various blues together in one puddle gives a very disappointing result; lay them side by side and they enhance each other.

Delphinium

I took the opportunity when a very dark blue delphinium was in flower to have a closer look at it. I painted the helmet-shaped heads with a weak mixture of Cobalt Blue with some Permanent Rose, the darker blue with French Ultramarine and Permanent Rose. The face of each flower was much more vivid and required Permanent Blue, French Ultramarine Blue and Permanent Magenta. The slender stem was tinted with the same blue purple.

With the aid of a magnifying glass I could really see the rich combination of blues present in each flower. The outer petals were a vivid blue. Permanent Blue deepened with French Ultramarine Blue made this intense colour. The inner petals were a rich purple bordered with blue, and the indented folds required an even richer red purple. Permanent Magenta partially mixed with Permanent Blue made the purple both rich and lively.

The tongue had a turquoise sheen to it, and for this I used Cerulean Blue tipped with Cadmium Yellow Pale shadowed with Cobalt Blue. The shredded white centres were left white with a few gentle shadows. Seeing one flower thus enlarged was fascinating and made me want to explore other flowers with the magnifying glass.

OPPOSITE This painting shows delphiniums, Canterbury bells, pansies and forget-me-nots; each magnified flower reveals the details of all the blues involved. Gardeners know that planting different kinds of blue delphiniums together makes a powerful display, so I have clashed the blues.
***Colours used:** Cerulean Blue, Cobalt Blue, French Ultramarine Blue, Permanent Blue and Prussian Blue, Permanent Rose and Permanent Magenta, Cadmium Yellow pale and Gamboge.*
***Paper:** Bockingford 140lb/300gsm.*

Pansy

The pansy was my next choice. Under the magnifying glass the various blues, purples and black velvet markings were revealed. Leaving the apron petal until last, I wet the others and then dropped some Cerulean Blue into the wet, following this with Cobalt Blue and a touch or two of Permanent Rose around the edges. The pigment mixed and travelled in the wet without the further aid of the brush. As the shine dimmed I dropped in the velvet, using French Ultramarine and Permanent Magenta. Prussian Blue with Permanant Magenta darkened the velvet still more.

For the apron petal I used French Ultramarine partially mixed with Prussian Blue for the velvet. I dragged additional streaks of pure Permanent Magenta across the apron. The centre was painted with Cadmium Yellow Pale, deepened with Gamboge. For the normal sized pansy the colours were similar but less intense.

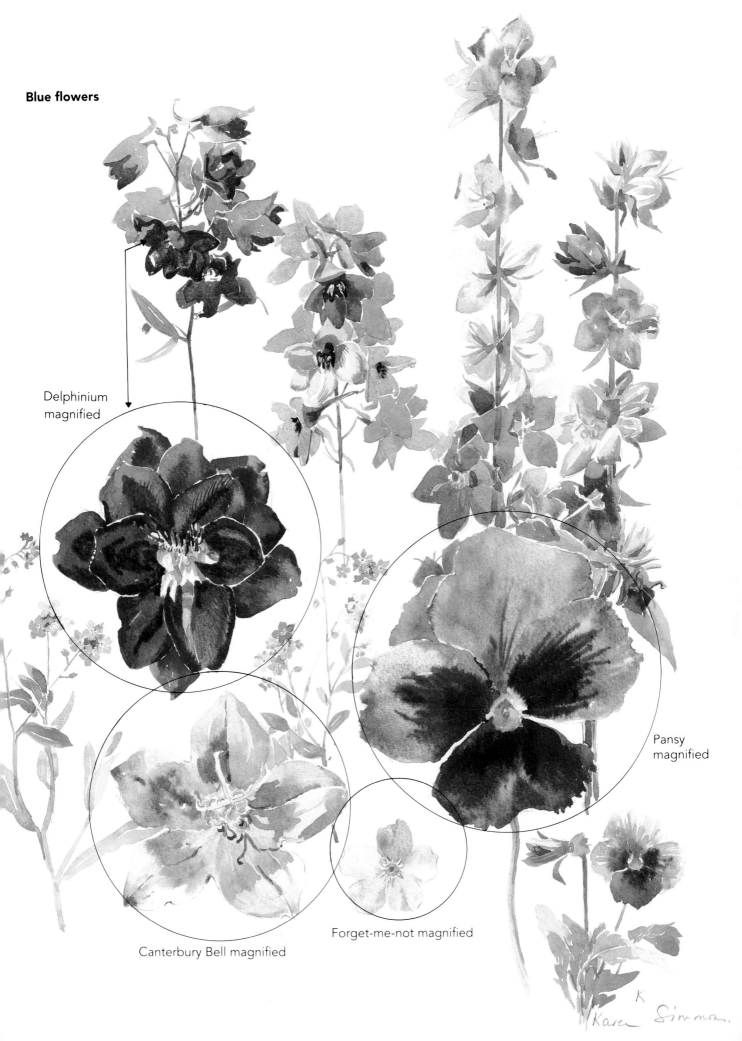

Blue flowers

Delphinium
magnified

Pansy
magnified

Canterbury Bell magnified

Forget-me-not magnified

Karen Simmons

Canterbury Bells

I had wanted to paint the Canterbury bells for some time, but the season was passing, the flowers would soon be over. However, even with visitors around, I managed to attempt them.

The star-shaped florets were like shot silk, some against the light transparent and fragile, others deeper in tone and more robust. The buds were white, pleated with mauve and green, and ramrod-straight stems showed through some of the flowers.

The colours I used were dilute Cobalt and Cerulean Blue, and dilute and deeper Permanent Rose. French Ultramarine with Permanent Rose was needed in one or two places only. I could not resist putting one of these florets under the magnifying glass. The untidy tangle of the stamens could be seen white and yellow, on a cushion of pale green. The fine grooves could be discerned. They faded in the light and were more visible in the cup. The silky petals changed colour with every facet.

I found a few late forget-me-nots and painted them too. Each tiny floret seemed to have a variation on the blues and pinks which, when they are massed together, make a strong clear blue. Each floret seen closely under the magnifying glass looked so fresh and innocent I nearly heard its appealing cry of 'Forget-me-not!'

Morning Glory

(20 x 16in, 51 x 41cm)

OPPOSITE The day this was painted was very hot; the medium was more perspiration colour than watercolour! To keep the paper cool, I placed a wet cotton cloth under the paper and clamped both to my lightweight board. As the moisture evaporated from the cloth I was able to manipulate the paint for longer. I painted these in Australia in the bush near my daughter's home. The bright light in that country makes the colours extremely vivid. Timing was crucial. If I went out too early the flowers were not unfurled; by midday it was too late for they were turning pink, soon to twist and die. They are rightly named and look magnificent, draping the lantana and other vegetation with a mesh of spangled blue.

Colours used: *Cerulean Blue, Cobalt Blue, French Ultramarine Blue, Prussian Blue, Permanent Rose, Cadmium Yellow Pale and Cadmium Yellow.*

Paper: *Bockingford 140lb/300gsm.*

Morning Glory

This time I wet the whole paper generously with water and then dropped in some Cerulean and Cobalt Blue, where the morning glory flowers would be grouped, and some Cadmium Yellow Pale in readiness for some of the leaves. Some Permanent Rose with a little yellow was blushed in where the Lantana would appear. Then I let these colours settle and dry.

I re-wet the sections on each morning glory trumpet and added the deeper blues where the facets required the richer colour. I painted the five-pronged star with Permanent Rose, and intensified this where the curve took the pink into shadow. The leaf cast shadow was a very bright blue and was added after the rest was dry; for this I used French Ultramarine with a touch of Permanent Rose.

The flowers on the edge of the group were painted with less detail in order to suggest that they were out of focus. The leaves of the morning glory have a distinct shape, yet the layers of leaves dappled with sun and shadow confused the eye. Choosing the bright leaf in the middle to start with, I wet the area around it and blushed in some more blue and green. This cut out the leaf which I then shadowed with some more green.

I used the same technique on a few other leaves, adding a more yellow green behind the blue, and a darker green behind a light. Some leaves, such as the one in the lower foreground, were painted on the top. The leaves on the outer edge were treated as silhouettes and the colour weakened. The coral clusters of the lantana were suggested using Permanent Rose with some of the Cadmium Yellow, and for all the greens I varied the blue from Cobalt to French Ultramarine and the yellow from Cadmium Yellow Pale to Cadmium Yellow.

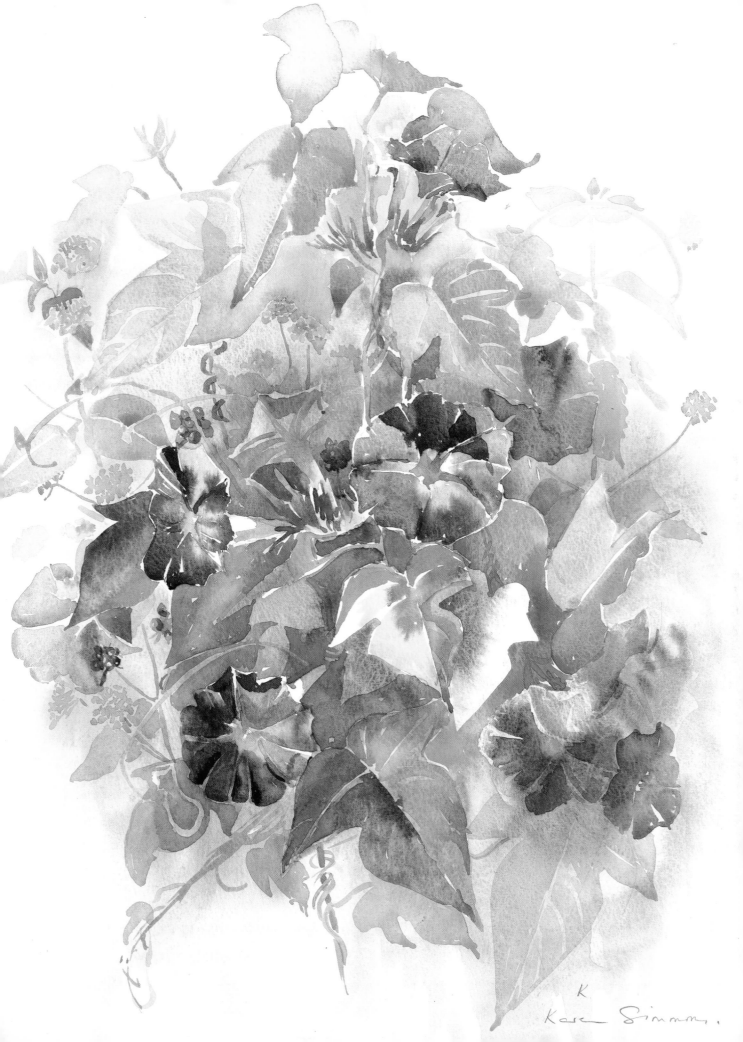

Kate Simms

Wild flowers

For those of us whose good fortune it is to have access to the countryside, the wayside and hedgerow wild flowers are a constant gift. The wild flowers grow in ditches, on banks, in fields and woodlands. Churchyards often have a part that is left to the wild flowers, which is where I find some of my subjects. Each season brings a fresh delight, passing all too swiftly to the next.

Individual flowers may be small and make little impact on their own but when they grow in groups the colours are amplified. For the painter, the prospect of painting the tangle of wild flowers, grasses and brambles is daunting: where and how to begin?

I look closely to see how the flowers are grouped and may find, for example, that there is a group of pink campions, a group of yellow buttercups, and white or mauve flowers making patches of colour. When I observed this I found that grouping the colours in the same way rather than scattering them would give the painting more cohesion. And so the 'blushing technique' evolved.

For this, I wet the paper generously, then drop the appropriate pinks and yellows in where the groups are planned to be. I allow the colours to disperse and even mix a little, and then wait for the paper to dry. The shapes of the flowers are then cut out by deepening the tone and colour behind, making that first blush become the colour of the flower. Other flowers can then be painted on top.

As the painting proceeds, these foundation patches of colour hold the painting together. This method is described in a step-by-step example in *A Spill of Daisies* on page 59.

Bluebell Wood

I drew the saplings with some care and planned the foreground bluebells. I took my wet brush around the saplings and flooded the rest of the paper with water. I partially mixed (they separate anyway) Cerulean Blue and Permanent Rose and then dropped this colour in along the horizon line. I deepened the colour with Cobalt Blue and French Ultramarine Blue, always keeping a little Permanent Rose in the mixture. I let the colour fade out completely lower down.

When this was dry, I studied the bluebells at my feet: the little faceted bells had turquoise at the top, the shafts were blue, the curl back of the bells sometimes pink, and the buds a dark, almost indigo, blue. I tried to convey this clash by laying each colour side by side, letting the colours blend themselves. After this stage had dried I darkened some of the shadowed facets with a stronger blue.

The fleshy stems were a pale green tinted with some of the reddish purple. The

Bluebell Wood

(20 x 16in, 51 x 41cm)

OPPOSITE That vivid sweep of blue in an English woodland in early May makes one catch one's breath, and the scent of bluebells is impossible to describe. The light falls through the thin Spring foliage and dapples the bluebells with an even deeper blue. There is birdsong all around … by now you may have the impression that violins are playing! I know that the bluebell woods are achingly missed by those who live out of the country and still remember them.

Colours used: Cerulean Blue, Cobalt Blue, French Ultramarine Blue, Permanent Rose, Permanent Magenta, Cadmium Yellow Pale, Cadmium Yellow and Raw Umber.

Paper: Bockingford 140lb/300gsm.

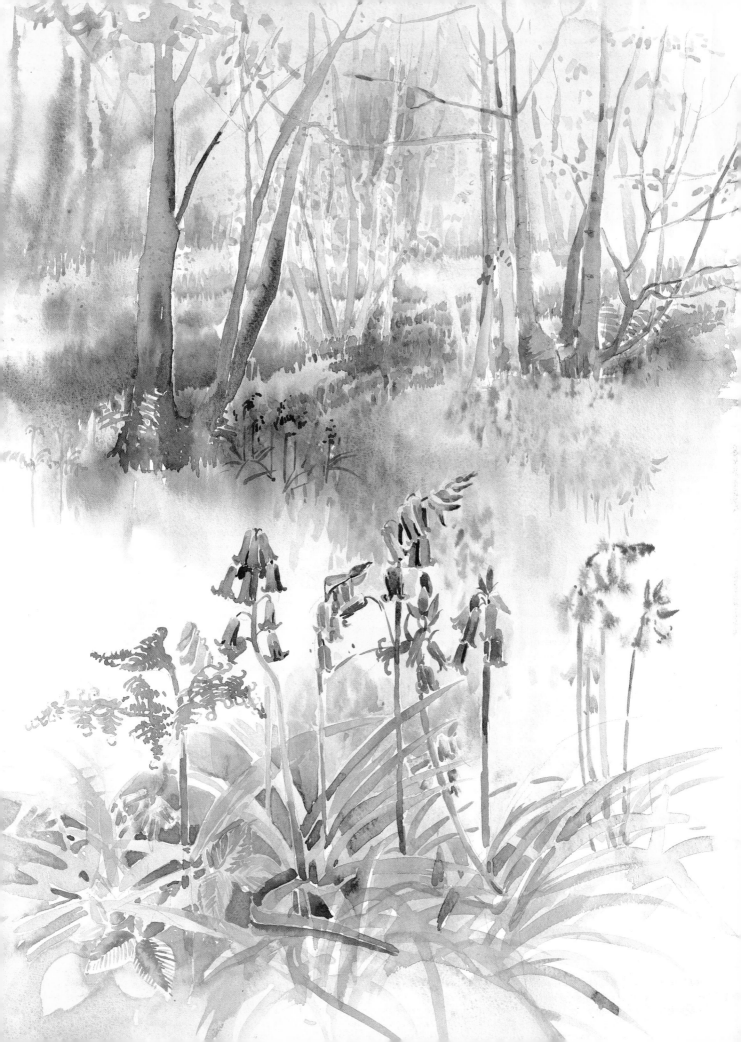

leaves splayed out from each one but tangled across the next. I noticed with delight the unfurling bracken and the newly pleated bramble leaves.

For these foreground greens I mostly used Cadmium Yellow Pale with diluted French Ultramarine Blue. Where the green was too lively I tempered it with some Permanent Rose. Later the darker greens could be painted into some of the space shapes. As it happened this painting was interrupted but I was able to return to the exact spot by recognizing the saplings from my drawings!

The difficulty with bluebell woods is the young green of the beech leaves: in the wood it looks fine; when painted it looks sickly. I use Cadmium Yellow Pale and Rowney Raw Umber to make a lime green which conveys the colour without looking too rich. Raw Umber varies in different makes of paint and this is why I have specified Rowney. Their Raw Umber is a true greeny brown. The saplings were also painted with this lime green and I added some Permanent Magenta to this for the stronger tones. Lastly I deepened the dappled shadows with some more purpley blue.

There is always a sense of disappointment at the end of a painting. Failure to catch what has inpired you leaves you in despair. Look at your painting a day or two after you have finished it. If you painted it with sincerity, it will recall the birdsong.

Meadow Daffodils

I returned from overseas in time for the English Spring and I saw the yearly miracle with new wonder. There they were dancing and fluttering under the apple trees (opposite). Would I do a close up? Or stand back and attempt the whole scene? I did both. I did this one first; the close up is on page 36.

The broken light and rippling shadows attracted me. The apple tree trunks and main branches were drawn first, then a few twigs. I made sure that the joins were convincing. Other twigs could then be added at will and with less care. I lightly drew the front clumps of daffodils and plotted a few of the others. I kept the front daffodil heads white and dry and wet the rest of the paper. I flooded in some Aureolin with the faintest blush or two of Cobalt Blue, where later I might need leaves or shadows. These two colours fused together to make a light airy green in places. While I waited for this preparation to dry I tackled the apple trees. Aureolin with Rowney Raw Umber was used, deepened with a little Permanent Magenta. Some grey mauves were made with Permanent Magenta and Cobalt Blue muted with a little green. When this was dry, I noted and painted the twiggy shadows.

The distant daffodils were suggested with a dancing brush loaded with more Aureolin. In the middle distance these movements were on a slightly bigger scale. The ones in the foreground however were painted more accurately and here I preserved some of that precious white. I then went back and painted the deep yellow trumpets with Gamboge.

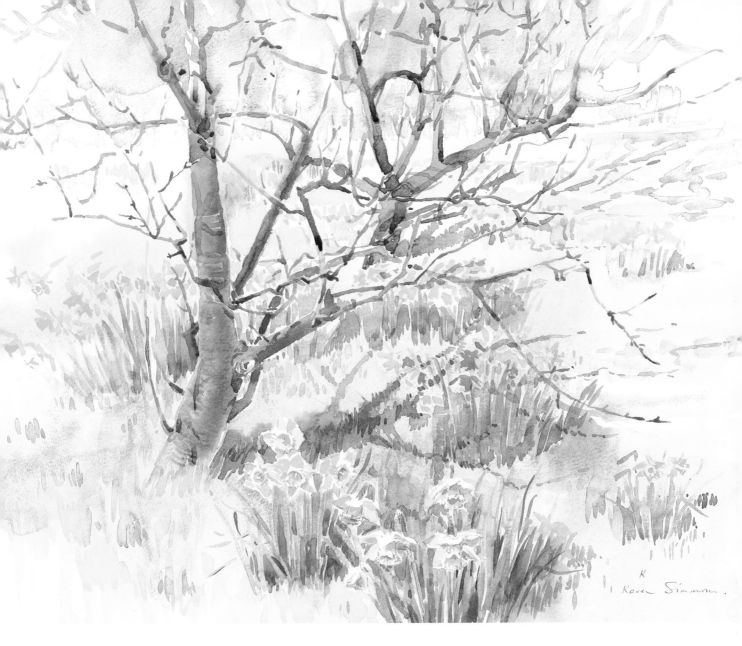

For the shadows that flickered across the daffodils I made a mixture of Permanent Magenta and Cobalt Blue, adding in some Gamboge. This had to be diluted to a suitable tone before being applied. Diluted still further, this mixture was dropped into a re-wet background at the top of the meadow.

The bladed leaves, some blue, some green, were stroked in with an upward movement. Some were painted with a weak solution, some with a stronger one and allowed to bleed along. A few shadowed interval patterns were observed and darkened. The cast shadows from the trees were painted keeping some soft and some defined.

The day was fresh and breezy and I hoped the painting would give that impression.

Meadow Daffodils
(16 x 20in, 41 x 51cm)
A bright breezy day and daffodils under the apple trees formed the invitation to attempt this painting.
Colours used: *Aureolin, Gamboge, Permanent Magenta and Cobalt Blue.*
Paper: *Bockingford 140lb/300gsm.*

Primroses

I drew the primroses, using a soft 4b pencil, very lightly, and planned some of the leaves. I kept the main heads dry and white, washed the rest of the paper over with water, using a big mop brush, and flooded in Aureolin. I had a cup of coffee from my thermos flask while I waited for this all to dry.

I painted Aureolin into the primrose faces while still preserving some petals and facets as white. A mixture of Cobalt Blue and a trace of Permanent Rose made a blue violet, and with this combination I glazed over the pale yellow petals to achieve a gentle shadow.

For the crimped primrose leaves, I prepared the texture by scribbling with a wet brush, and then dropped a fresh yellow green into the wet, letting the colour run along the prepared lines. I added some deeper greens at the tip and along the edges. Stronger shadows were added afterwards. For the greens I mostly used Aureolin and Cobalt Blue, and occasionally the Cadmium Yellow with the blue. Deeper greens called for French Ultramarine and Cadmium Yellow. The leaves at the top were suggested with less texture and painted a sky-related blue, and those to the side or underneath with the duller mixture of French Ultramarine Blue with Yellow Ochre. At the top of the clump some blue sheened grasses were painted, and also some greener ones.

To convey the thin roots and fine dry grasses I painted negatively – that is, I deepened the colour around and between them. I obeyed the tiny space shapes and patterns that were made by the interweaving threads. I varied the tones, darkening still more in places. At the end I glazed some shadows over a few of them. The dark ivy was seen, some behind, some in front of, the grasses. These and their vines were painted, changing the tone from light to dark.

It remained to re-wet the background at the top right side. A mauvey grey mixture was dropped in and some Yellow Ochre was added lower down. Two or three wet primroses appeared and some more grasses. The dry oak leaf and other details became attractive; it was time I stopped!

I was cramped and cold by now and did not know if I had a painting or not. It is a good idea to prop up a new work in the house where you pass by. Look at it for a few days and anything that needs adjusting will become apparent.

Primroses

(16 x 20in, 41 x 51cm)

*RIGHT These fresh-faced primroses emerged on
a bank after Winter, pushing through last
year's grasses and weeds with dead leaves still
clinging to them. Ivy twined its way along the
ground, but some young grass was also
appearing. To get level with them I sat on my
dustbin bag on the ground.*

Colours used: *Aureolin, Cadmium Yellow,
Yellow Ochre, Permanent Rose, Cobalt Blue and
French Ultramarine Blue.*

Paper: *Bockingford 140lb/300gsm.*

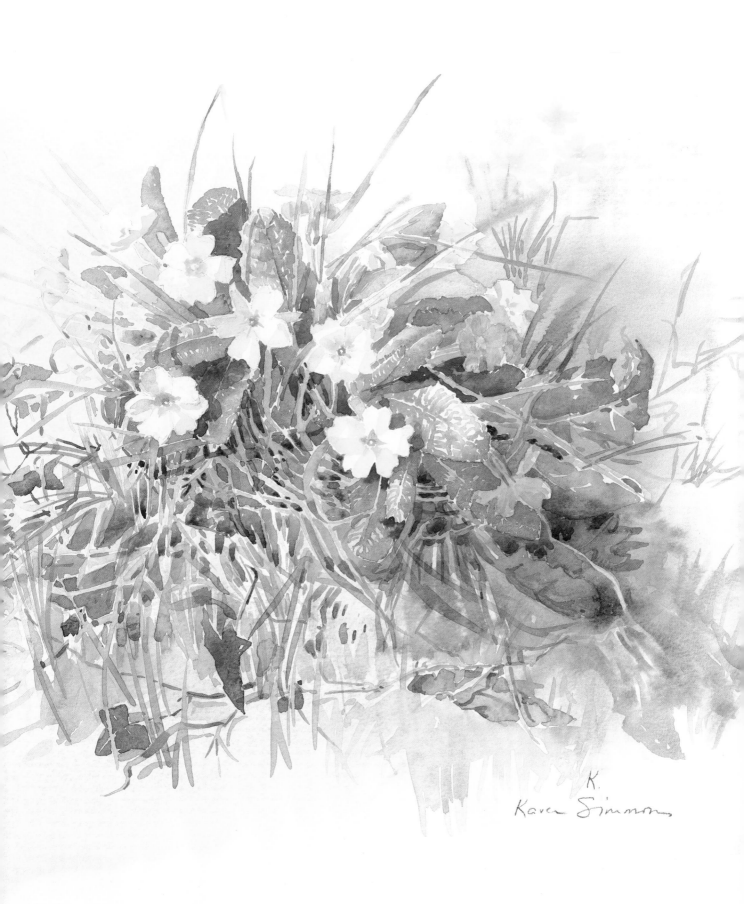

K.
Karen Simmons

The Iron Stream

I arrived with my painting gear, rather like the Prince finally getting to the Sleeping Beauty, somewhat scratched and battered. So profuse were the wildflowers it was hard to know where to put my feet or place the dustbin bag. I made a couple of sketches to see which composition would benefit the subject most. The 'story' was the stream, seen from deep amongst the flowers (opposite), so I chose the vertical shape. Once plotted and drawn I used some masking fluid on the Queen Anne's Lace and made smaller marks for the distant ones. Then I wet the whole paper and quickly blushed in the yellows and pinks, even where the stream would be painted. This time the masking fluid would be preserving the whites.

I painted the foreground campions as soon as the paper was dry. Some of the pink blush became the lighter petals and I painted a deeper Permanent Rose where it was needed to describe their ragged profiles. The exciting brown red of the calyx and buds was done with Permanent Rose combined with Light Red. Nature had again clashed her colours. I added a little Cobalt Blue to the Permanent Rose when I needed the mauves.

The light petals of the buttercups were already there from the yellow blush. I emphasized a few more with Cadmium Yellow. Gradually the leaves were painted in, with respect to their shapes and colours. To adjust the background behind the foreground flowers, I re-wet this area, deepening the colour in places or cutting out a leaf from an earlier blush such as one of the sorrel leaves.

The flowers on the far bank were only suggested. The landscape beyond needed to be painted softly so that it kept its distance. The stream was painted with Light Red, a little Permanent Rose muted in places with Cobalt Blue. I washed these colours in, bringing the brush downwards. When these colours were dry I painted the shadows lying along the surface of the opaque stream. The reflections from the banks of flowers were largely there from the first blush. Finally I added a few ripples; these did go across.

When everything was truly dry I removed the masking fluid, either with my thumb or a soft eraser. Masking fluid does not come off quite so easily from Arches paper as it does from the more heavily sized Bockingford, and stale masking fluid can cause problems. With the masking fluid off I made some final adjustments.

I pushed my way out again through the thicket trying to protect my painting from the claws of the brambles. Why do I do it?

The Iron Stream

(24 x 19in, 61 x 48.5cm)

OPPOSITE The stream received its name because the presence of iron did indeed produce this rich brown. It was surrounded by clouds of Queen Anne's lace, buttercups and campions. There were also hawthorn hedges, nettles and brambles through which I clambered to reach this intimate pocket of paradise.

Colours used: *Cadmium Yellow Pale, Cadmium Yellow, Permanent Rose, Light Red, Cerulean Blue, Cobalt Blue, French Ultramarine Blue.*

Paper: *Arches 200lb/425gsm.*

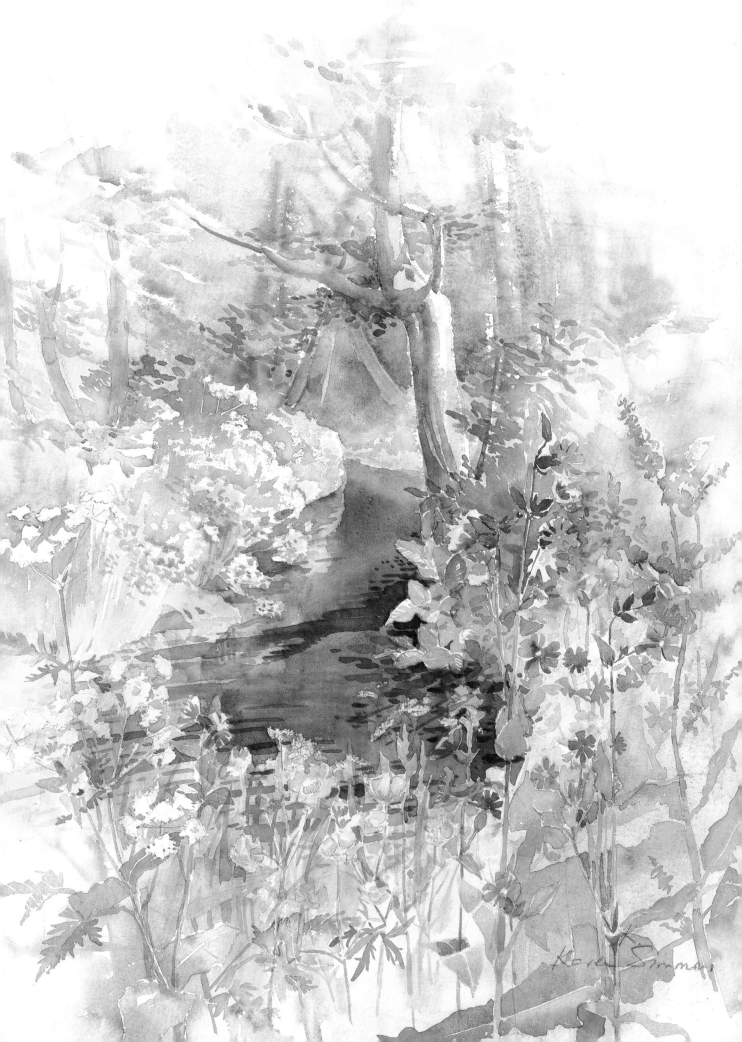

Foxgloves

I sat down on my dustbin bag in order to be level with and amongst the flowers. I boxed the foxgloves so that when I drew all the bells they would fit. The daisy heads, too, were boxed and drawn showing their angles and missing petal gaps like missing teeth.

Having wet the whole paper, first going carefully around the white flowers, I blushed in the yellow using both Cadmium Yellow Pale and Gamboge. This was in preparation for the *lotus uliginosus* which resembles a giant yellow clover. Light Red and Permanent Rose blushes were dropped in, and also some bluey greens with which I stroked in some out-of-focus grasses on the left. I then placed the bright centres to the daisies with a little shadow to describe the raised cushions. Leaving the very pale pink frill almost white, I painted the inside of the foxglove trumpets with a coral pink, mixing the yellow with Permanent Rose. The dotted markings were added later.

The sharp pink of the bells were coloured with Permanent Rose, faceted with a richer red using Cadmium Red, even Light Red mixed with Permanent Rose. The shadowed daisies on the left were carved out by re-wetting around them and deepening the wash behind. By adding a leaf or two to provide contrast they showed up well enough. Their darker centres were painted with Yellow Ochre and Gamboge.

More leaves, weeds and brambles were suggested, some lighter than the background, others darker. The tall silhouetted foxgloves indicate more flowers behind, and these added depth to the group.

Foxgloves

(20 x 16in, 51 x 41cm)
OPPOSITE I found this group of flowers at the edge of a wood in Scotland when I had little time to paint. It was early July, the weather hot and the nights hardly dark at all. I used the same blushing method as for the other wild flower paintings, but this time I did not use masking fluid but went patiently around the daisy heads and foxgloves with a wet brush.
Colours used: *Cadmium Yellow Pale, Gamboge, Permanent Rose, Cadmium Red, Light Red, Cobalt Blue and French Ultramarine Blue.*
Paper: *Bockingford 140lb/300gsm.*

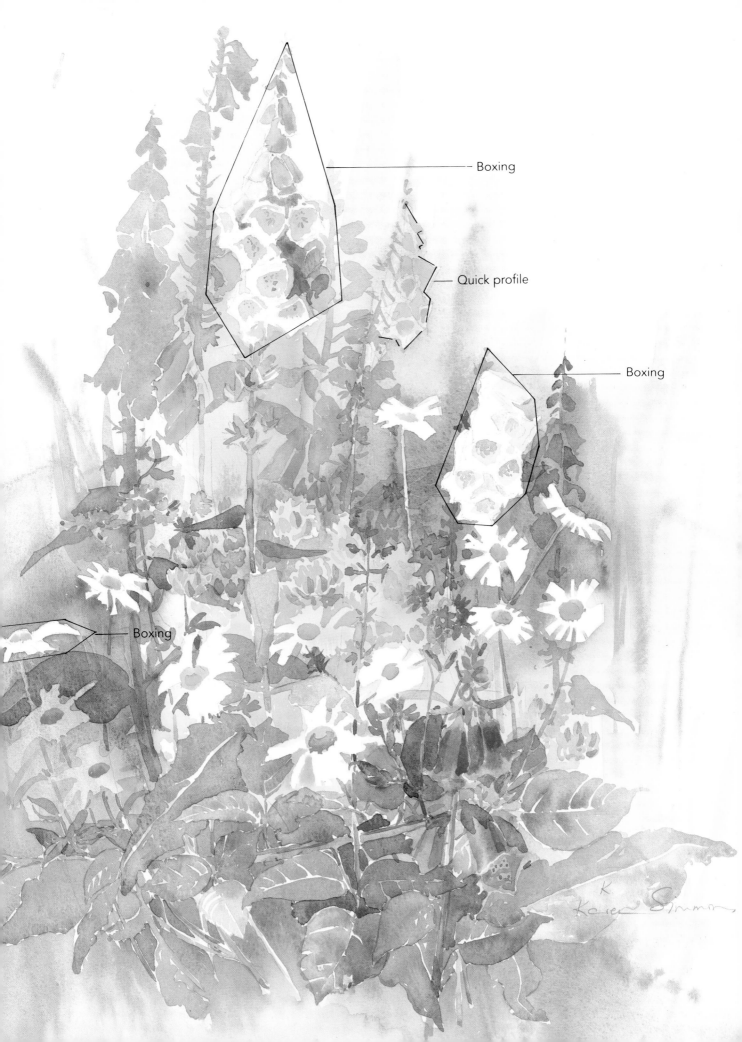

Boxing

Quick profile

Boxing

Boxing

A Spill of Daisies
(16 x 20 in, 41 x 51 cm)

The moon daisies had been knocked down by a heavy storm but were already turning their heads up again to the light. The rhythm of the stems and grasses was the attraction this time and dictated the horizontal composition. I plotted and boxed the daisy heads in islands or groups before invading the petal shapes (see stage 1 on page 60). The stems were drawn in to establish the rhythm, and then the clovers and buttercups were planned in the same way. As there were so many daisies I used masking fluid and once this was dry I could splash in the blush colours with freedom, streaking the blue-sheened grasses across the foreground.

The blush colours were dropped in where they would be needed (see stages 2 and 3 overleaf), the Aureolin where the buttercups were grouped, and the Permanent Rose where the clovers were clustered. Some green background was prepared. Light Red with Yellow Ochre was spilled across the middle and the darker blue greens were dropped in towards the top. As the paper was losing its shine, some out-of-focus grasses could be suggested. In haste, the sorrel was also dotted in with the point of the brush. So far I had had to work fast, hardly breathing for excitement.

When all this flooding and blushing had dried I deepened the yellow behind the buttercups. I re-wet a generous area, working carefully around the buttercups, then dropped in a mixture of Aureolin and Gamboge letting it disperse away. Then I re-wet the area around the clover in the same way. Permanent Rose with a trace of Permanent Magenta was used to deepen the pink towards the daisy heads. The same method allowed some darker and richer greens to be used.

Going back to the buttercups, I painted the shadowed cups with Gamboge. Moving on to the clovers, I painted the tiny flutes first with Permanent Rose. Then I added some Cadmium Red at the base and watched it travel upwards. I deepened the colour between some of the foreground grasses.

My concentration was flagging so I packed up my things. The next day the scene had changed – the dramatic knapweed with their nearly black stems were interwoven with the buttercups. I could not resist adding in a couple of orchis which were growing in the undergrowth, a yard or two away. To convey the light grasses I re-wet the sections between the grasses leaving the finest gap. I deepened the tone of these intervals using diluted Light Red mixed with Permanent Magenta. The fine grasses then emerged from the first golden blush. The grasses showing against the dark green at the top were painted in the same way. When all was reliably dry, I scraped a few more grasses in with a razor blade. At last I could peel off the masking fluid and reveal all the white daisies.

I painted the bright yellow buttons and the deeper tones which shaped them. Then it was time to paint in the shadows on the daisies describing the tilt to the head and the curve of the petals. I used some dilute Cobalt Blue where the shadows were a true blue, then added in a little green for those in the top middle. The ones at the top left-hand corner were Cobalt Blue with a touch of Permanent Rose.

I painted the grey clover leaves and the bright green buttercup leaves. The leaves of the sorrel had begun to turn and made a lovely patch of colour behind the buttercups and orchis. It was high time I stopped before I added anything else.

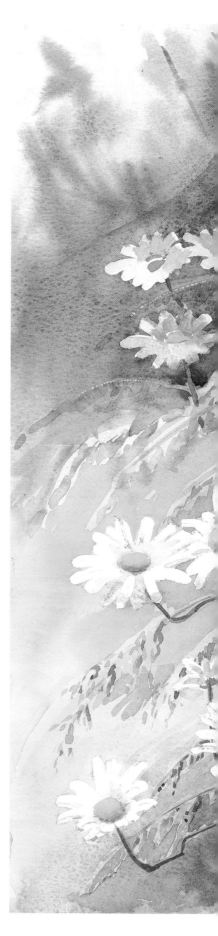

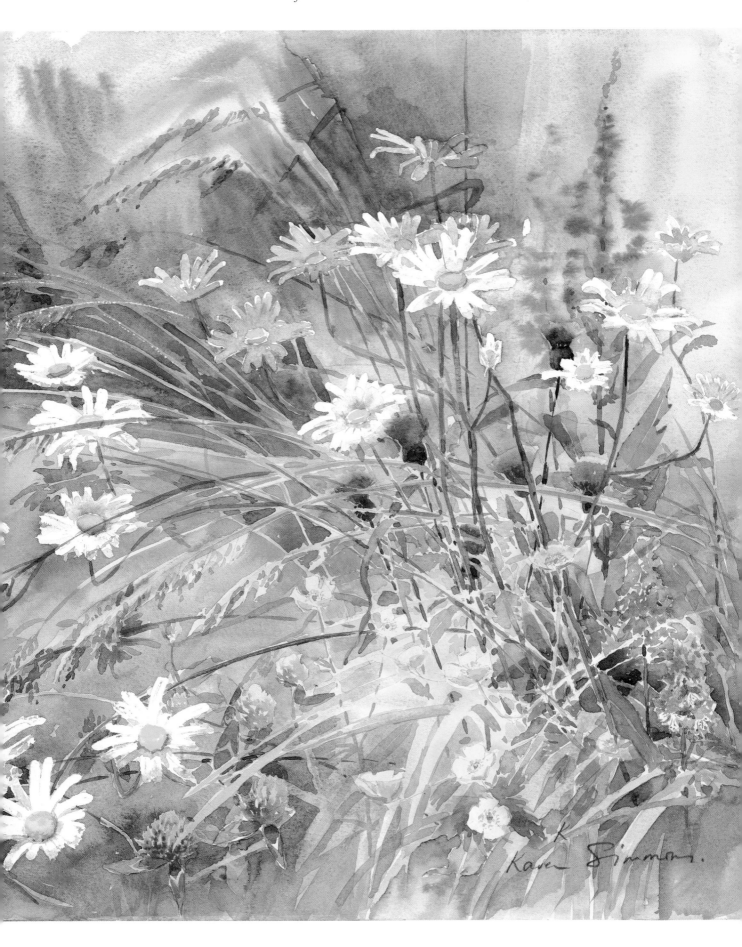

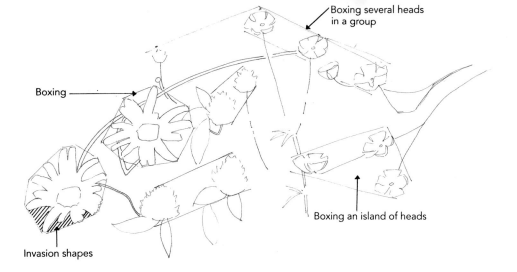

Boxing several heads in a group

Boxing

Invasion shapes

Boxing an island of heads

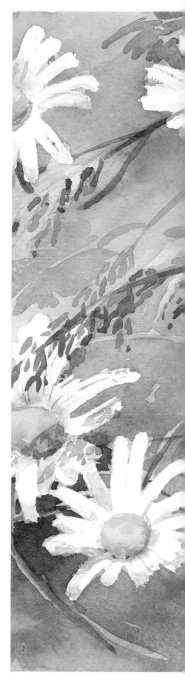

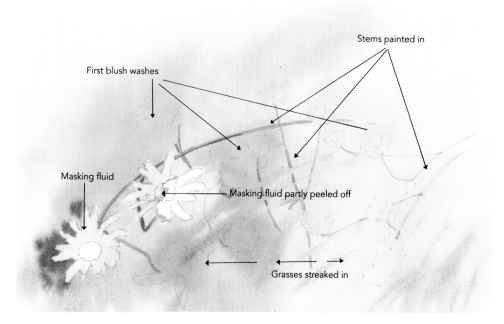

Stems painted in

First blush washes

Masking fluid

Masking fluid partly peeled off

Grasses streaked in

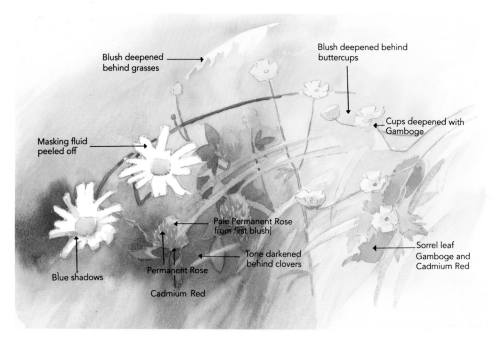

Blush deepened behind grasses

Blush deepened behind buttercups

Cups deepened with Gamboge

Masking fluid peeled off

Pale Permanent Rose from first blush

Tone darkened behind clovers

Sorrel leaf Gamboge and Cadmium Red

Blue shadows

Permanent Rose

Cadmium Red

60

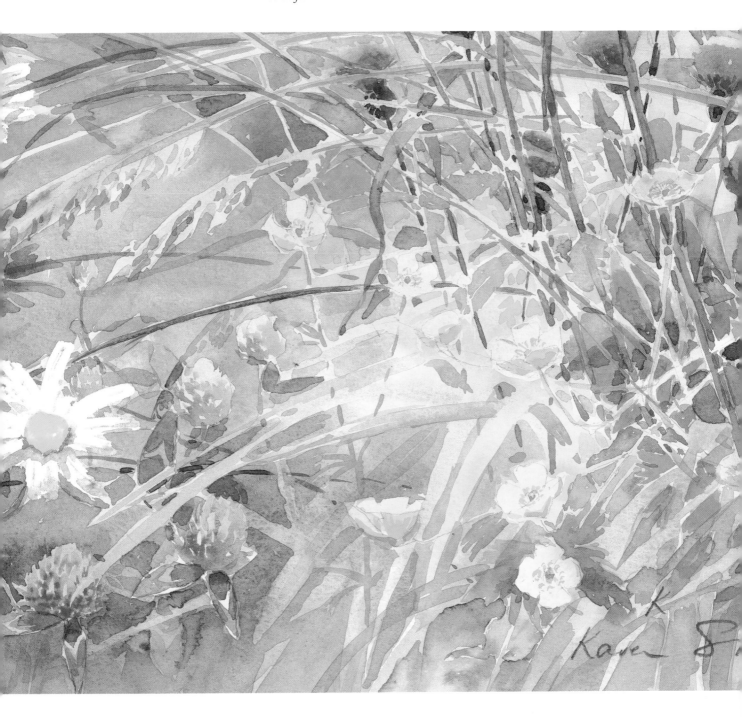

ABOVE *A detail of the finished painting,* **A Spill of Daisies***, on page 59.*

LEFT *In the stage-by-stage examples you can see how the blush technique holds all the elements together, eliminating all but the necessary whites. This method can prevent a fragmented result. Observing the stem rhythms early on can also help to keep the painting on course. It is no easy matter selecting a few heads and stems from the muddle of weeds and grasses in front of you. However, I do find this approach helps me to build the painting in easy stages.*

Poppies in Turkey

The group had composed themselves just as you see them. I began by plotting the heights of the poppies in relation to each other and the mallow that reached forward. I then drew the rocky white stones. The stones were left dry and white as I wet the rest of the paper. I blushed in the areas of yellow, blue and pale magenta in preparation for the flowers. The silky poppy petals were fluttering in a light breeze. Sometimes they showed pink where the light caught a sheen, then orange where the light glowed through them. Deep strong reds accented the shadows.

I noticed I had two types of poppy here, the tiny ones as fragile as tissue paper. I used Permanent Rose for the pink sheens and undercoated other areas of the poppies with Gamboge. I then came back to add the Cadmium Red, thinly in places, at full strength in others. The little dark patches were painted using Madder Brown. The bright blue pimpernels were clustered in a vivid group behind the poppies. Moving on to the pale blue blush, I painted the little heads using Cerulean Blue with French Ultramarine Blue. The tiny centres were detailed with Permanent Rose.

The yellow daisy-like flowers only needed a deeper Gamboge in places to define their shapes from the yellow blush. Behind them was a group of lungwort with flowers of pink, mauve and blue on each stem, all clashing! The foreground mallows were painted with Permanent Magenta, well diluted, and shadowed with some Cobalt Blue. The fine lines were painted with Cadmium Red mixed with Permanent Magenta, but in shadow a stronger Permanent Magenta tinged with blue seemed the right colour to use.

The rocks were patterned with the shadows cast by the flowers and stems. These were mostly painted with Cobalt Blue with a trace of Permanent Rose. Around the rocks, and in and around the mallows, I re-wet the paper, then dropped in some French Ultramarine Blue with Madder Brown. This exploded in the wet travelling outwards. I deepened under the rocks with more of the rich Madder Brown. I prepared the area to the right of the rocks in the same way but used Raw Umber first and then a little Madder Brown. Lastly I painted in some of the delicate grasses that were growing with this group of colourful wild flowers.

Poppies in Turkey

(20 x 16in, 51 x 41cm)

These wild flowers grew on a bank close to the shore in southern Turkey. The poppies, pimpernels and mallows were scattered across white stones which were patterned with their shadows. They made a natural composition. Eager to start, I set up my easel and, looking around, discovered an old rusty oven abandoned on the beach. I dragged this nearer and used it as a table for my paints.

Colours used: *Permanent Rose, Permanent Magenta, Cadmium Red, Cadmium Yellow Pale, Gamboge, Cobalt Blue, Cerulean Blue, French Ultramarine Blue, Madder Brown and Raw Umber.*

Paper: *Bockingford 140lb/300gsm.*

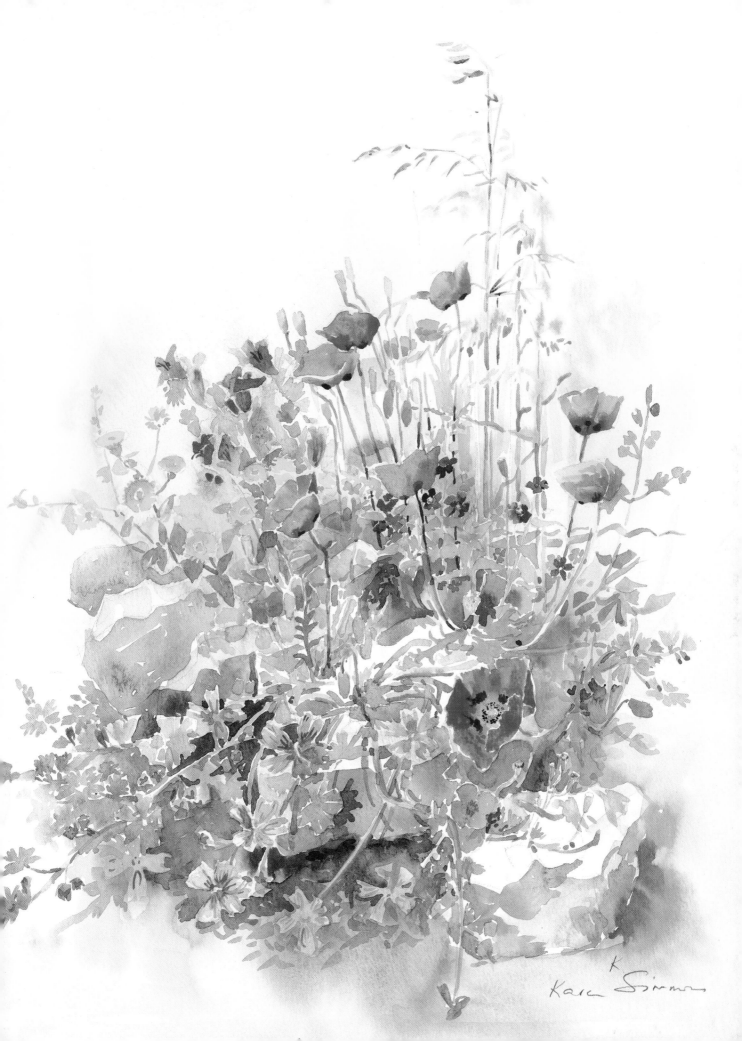

Flowers in the landscape

In this chapter, flowers are part of the scene rather than the 'story'. Indeed, the chapter may well have been titled 'Landscapes that happen to have flowers'. Flowers add splashes of colour to the subject and give pleasure to the viewer. They become a vivid reminder of the place and season in which they were painted.

Fodder for the Donkey

I was able to prop my board on a stone wall and spread my things along the top. I stood and gazed at the little allotment and the derelict building which lay at the foot of a steep rocky slope to which olive trees clung in shallow terraces. In front were the vegetables, broad beans, onions and some potatoes. A vine or two straggled across the stony ground. The same flowers as I had painted the day before were here in profusion along the path.

I plotted the composition, leaving the sky out. The hillside was so steep that even if I had wanted to put the sky in it would have been too small a shape. By leaving it out the floor of the allotment could keep all the stage lighting. From my sketch I placed the little lady with the bundle on her back into the scene.

When I started to paint I wet the paper above the roof to the top. Then I washed in some dilute Light Red. As soon as the shine had gone but with the paper still damp I painted the olive trees using Cerulean Blue and Yellow Ochre. These two colours separate and with the Light Red made both the colour and the texture for the olive trees. While I waited for this part to dry, I painted the sun-bleached roof and the shadowed stone walls. Returning to the hillside I suggested the terraces and some more olive trees in the distance. With the deeper blue tone I was able to cut out the nearer tall trees.

The figure was painted next. Keeping a white edge to the bundle and to her head and shoulders, I painted her colourful pink top, her pale trousers and the darker skirt. A shadow was cast before her on to the path and I painted this a reddish mauve. The patches of vegetables bleached by the downlight were only textured at the side. Light Red and Yellow Ochre were used for the colours between the vegetables and around the vines, the grasses and flowers being only suggested.

A final touch was the dark doorway and the cloth hanging on the door. The vine post, the figure and the door led the eye along the path.

Fodder for the Donkey
(17½ x 14in, 44.5 x 35.5cm)
OPPOSITE The little Turkish woman was walking along the path, on her back a bundle of fodder for her donkey. She was wearing pink trousers, a bright top and typical national headgear. I quickly sketched her into my sketchbook, so that I could put her into the painting. I noted the light on her shoulders and on the bundle and also how far her head came from the distant wall and where her feet were placed. All around her were the same flowers I painted in **Poppies in Turkey** *(page 63).*
Colours used: *Cobalt Blue, Cerulean Blue, French Ultramarine Blue, Raw Umber, Light Red, Permanent Rose, Permanent Magenta, Cadmium Red and Cadmium Yellow.*
Paper: *Bockingford 140lb/300gsm.*

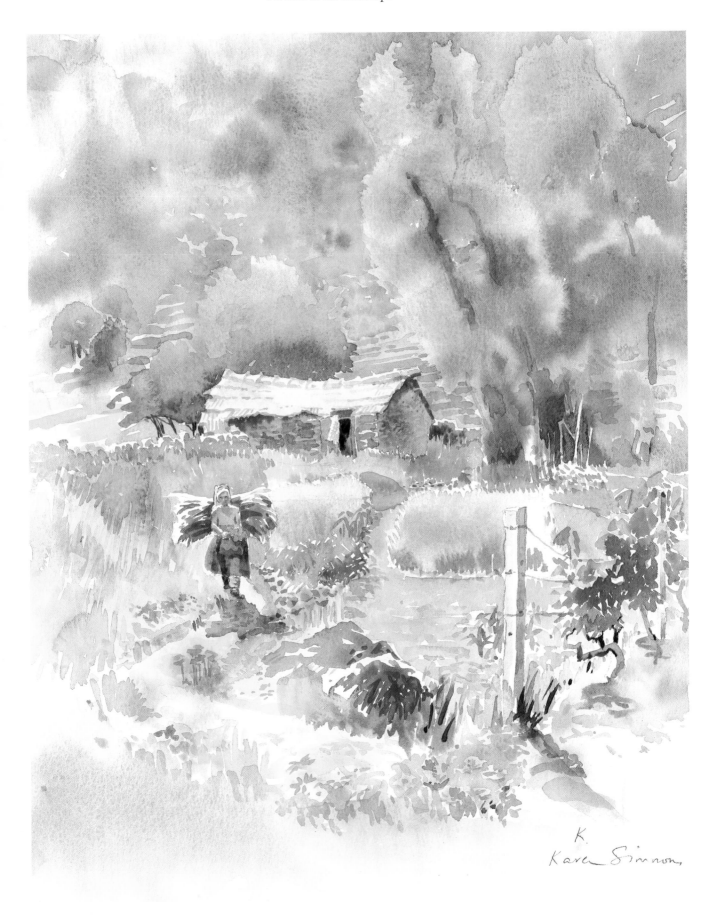

The Water Mill

The Water Mill

(12 x 10in, 30.5 x 25.5cm)
This is the water mill at Michelham Priory in Sussex. It was Spring, the trees not yet in foliage, but the bank sparkled with white wild garlic and daffodils. Closer to the dark mill stream were some marsh buttercups. That was just part of the attraction: the moving clanking wheel which patterned the slatted wall of the mill house with shadows was the story.
Colours used: *Cadmium Yellow, Yellow Ochre, Light Red, Raw Umber, Madder Brown, Cobalt Blue and French Ultramarine Blue.*
Paper: *Bockingford 140lb/300gsm.*

The Water Mill

I painted this straight off with the brush. No pencil marks – the compositional procedures had been done in my mind! I started with the walls of the mill house to establish the near-vertical of the building. I used Raw Umber warmed with Yellow Ochre for the light wall and Raw Umber with Cobalt Blue for the shadowed facing wall, Yellow Ochre with a touch of Light Red for the sun-warmed roof facet, and Light Red cooled with a little Cobalt Blue for the shadowed end of the building and for the foundation of the brick and stone wall below.

The restored wheel was painted with Light Red and a touch of Yellow Ochre. Later, the strong shadowed blades were painted with Madder Brown. The shadow cast from the wheel was painted with Cobalt Blue which turned to green as it glazed over the warmer colours of the wall. The texture on the roof and on the slats was added when all was dry.

The trees were simply painted but the various colours and tones were observed. The front tree was profiled with ivy and painted with Raw Umber and French Ultramarine Blue. Some Light Red at the base helped to show up the twining ivy stems. On the lighter side, the ivy leaves appeared more green and were described by using Cadmium Yellow with French Ultramarine Blue.

The grass on the banks still had the ochre winter colouring with only a little fresh green appearing here and there. I painted some bright yellow marks for the marsh buttercups and for the daffodils on the nearer bank.

The areas of the wild garlic were left white with some wet blue marks added later for the stems and shadows. The glassy dark water was painted with Raw Umber, Cadmium Yellow and a touch of Light Red. I left the white path of the waterfall reflection and some white intervals to convey the ripples, and then added into the white reflection some colour the same as the light wall of the mill house.

The sky, mostly dilute Light Red with a little Cobalt Blue, was painted last. Behind the mill house, along with a few grey trees, the Norman tower was just suggested.

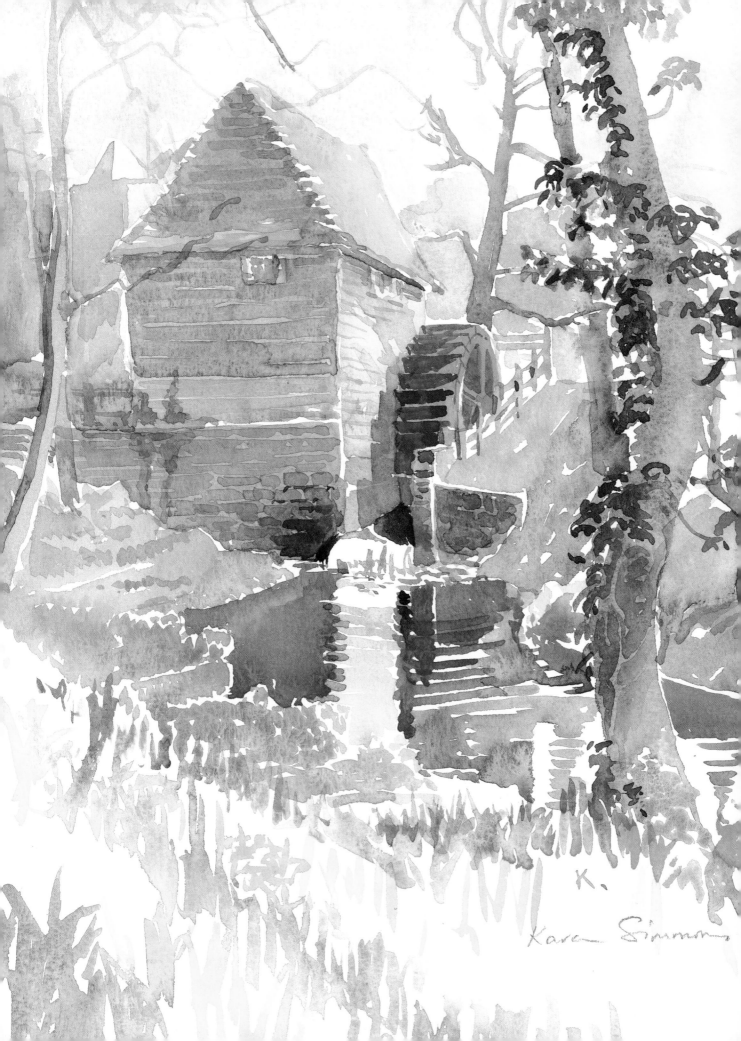

Turkish Washing Line

(15½ x 12in, 39.5 x 30cm)

I sketched this delightful subject very quickly. The little yard was crowded with fruit trees, medlars, lemons and oranges. The white iris stood tall in the cool shade, contrasting with the vivid geraniums in the bright sun. The flowers echoed the bright pink shirt on the line, and through the pointed arch was a domestic clutter of pots and jars. I shadowed the bright pink shirt and the pink geraniums with an orange red which made them glow, and painted the bright blue towel with Cerulean Blue, shadowed with French Ultramarine Blue to which a touch of Permanent Rose had been added. The dark of the arch behind the medlar tree was painted with Madder Brown, a red dark being more recessive than a blue dark. The little orange tree on the right was nearly silhouetted, so strong was the contrast against the bright sunshine beyond.

Colours used: *Cadmium Yellow pale, Cadmium Yellow, Cadmium Orange, Permanent Rose, Cadmium Red, Cerulean Blue, French Ultramarine Blue.*

Paper: *Bockingford 140lb/300 gsm.*

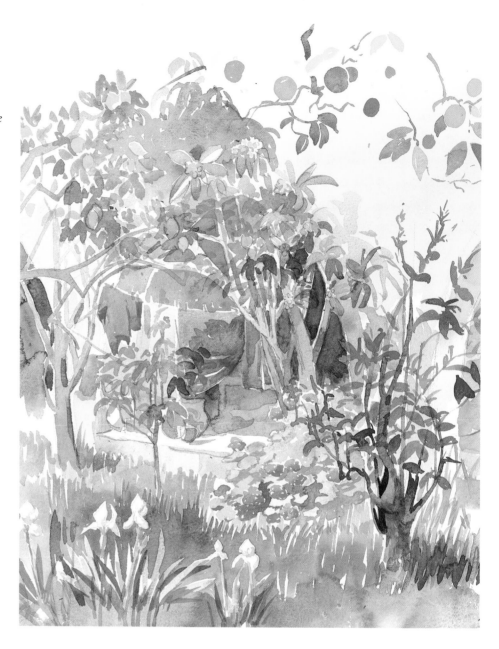

Blue Windows

(17 x 15½in, 43 x 39.5cm)

OPPOSITE *I had to climb up to have a closer look at this dazzling colour combination of white walls, bright blue windows and a cascade of pink and red flowers high above the road in a small coastal village in Turkey. Whitewashed olive oil cans serve as plant pots and look delightful filled with vivid flowers. The blue chairs are so picturesque, and so uncomfortable to sit on! Lower down, some heavily camouflaged chickens foraged in the long grass. In front of the house a young mulberry tree gave welcome shade. A woman appeared in the doorway and I mimed my request for permission to paint. She nodded, and shrugged her shoulders, probably thinking all foreigners were mad, especially artists. Her little solemn-eyed daughter offered me single flowers throughout the day, no doubt from her mother's garden. I was touched to receive these blooms and to gaze into the big, dark unsmiling eyes of the shy little girl.*

Colours used: *Cerulean Blue, French Ultramarine Blue, Cobalt Blue, Light Red, Yellow Ochre, Permanent Rose, Permanent Magenta, Gamboge.*

Paper: *Bockingford 140lb/300gsm.*

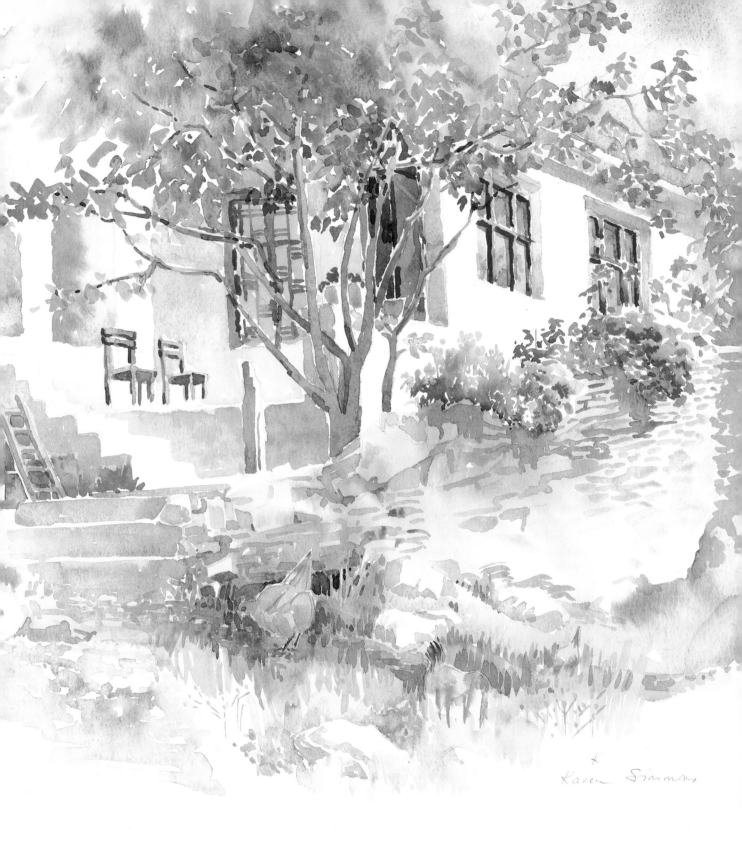

Karen Simmons

Flowers in the garden

It is very tempting, as well as challenging, to paint a beautiful garden. A private garden that has been lovingly planned and tended by the owner is a work of art. The gardener is in partnership with the Creator, and therefore finds the work deeply satisfying. Beds and shrubs are always planned for seasonal colour combination and textural interest. Those of you who have attempted painting such a subject will know the heartache and disappointments that attend these undertakings.

Not everyone has access to a garden but most people have a few pots. These too can make a delightful subject. Perhaps that would be easier? Alas, no! Flowers and plants inevitably have many small shapes and lots of texture, and the result can so easily look flat and over-busy.

I have found that establishing the volume before the texture helps the three-dimensional appearance of the tree, shrub, group or pots of flowers. You can suggest the identifying profile edge of the subject with the first colour wash. Then, by dropping in the deeper and darker tones underneath, you can establish the volume. The colours can be left to granulate, giving you a textural effect without having to work so hard for it.

An illustration of this method is the little pollarded tree in *Hotel Flower Beds* (page 75). If more texture is required, it can be added.

Summer Pots

(24 x 18in, 61 x 46cm)

OPPOSITE *A few pots can make a delightful subject. In this painting I concentrated more on the profile shapes of leaves and flowers and hardly at all on the texture. The underlying yellow blush isolated the crisp white petunias and held the composition together.*
Colours used: *Cadmium Yellow pale, Cadmium Yellow, Gamboge, Cadmium Orange, Cadmium Red, Permanent Rose, Madder Brown, Cerulean Blue, Cobalt Blue and French Ultramarine.*
Paper: *Arches 140lb/300gsm.*

This painting is demonstrated in my video Gardens in Watercolour.

Summer Pots

The pots that flanked the stone steps were bright with colour, the cast shadows had enticing shapes. I liked the way the thick rose stems created dark-toned shapes at the back. The snowy petunias in the front were dramatized by a dark pot just beside them. A lovely subject indeed, but how to begin?

It was important to give the subject a unifying foundation colour, so once I had drawn in the basic shapes I wet the whole paper, with the exception of the white petunias in the foreground. Into this wet I blushed some Cadmium Yellow which dispersed well and became quite pale. While this was still wet I established the darker greens and reds at the top of the steps. I needed to paint the shadows in while they were still there. To do this I mixed some purple, using Permanent Rose and French Ultramarine Blue which, being too bright, was adjusted by adding a little green. With this colour I painted the shadows on the steps and also used it to give the white petunias more definition.

The geraniums already had the necessary undercoat of yellow which helped to keep the red glowing. I painted the light tops with Permanent Rose first, and then

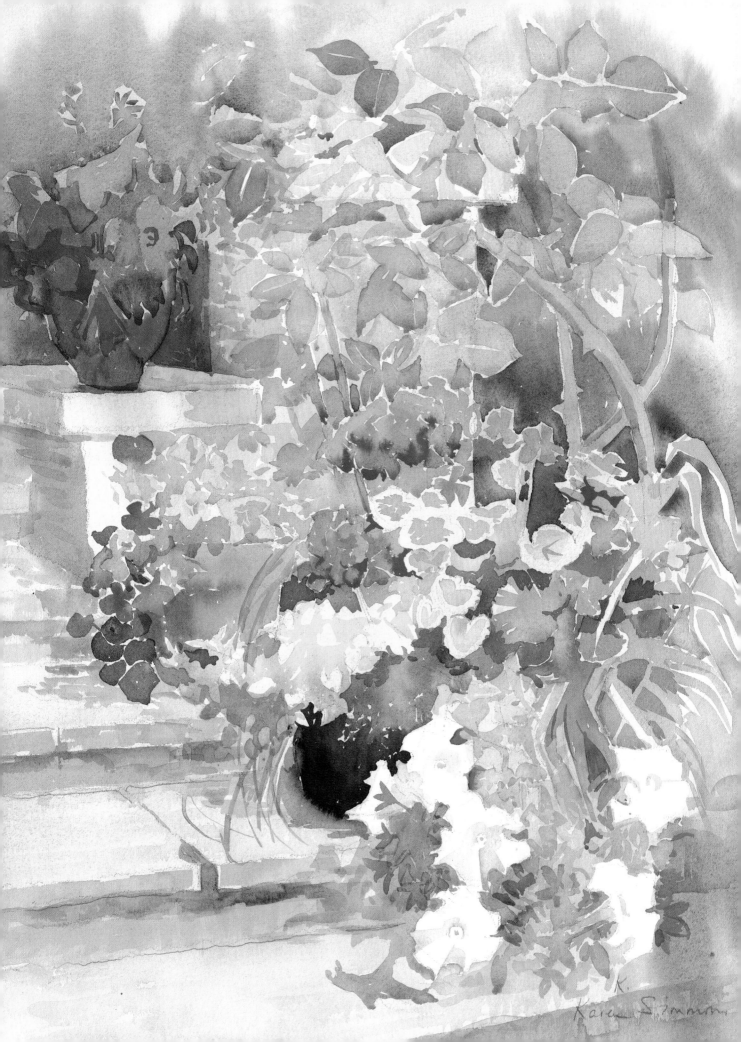

deepened them with Cadmium Red, thickening the mixture for the denser tone. This method helped to give the domed appearance to the geranium heads. Their leaves had light edges which I could convey with the undercoat; I needed only to paint the fresh green centre patterns. Cerulean Blue with a touch of Cadmium Yellow were the colours used for this green; for the dark green intervals and shadows I used French Ultramarine Blue and the same yellow.

The yellow leaves above and behind the petunias were produced by allowing some of the undercoat to show through. I deepened the yellow around some of the light leaf shapes and gradually added some Raw Umber to the yellow, which created a satisfactory lime green.

I painted the nasturtiums and flowers in the pot at the top as simply as possible, and the strong rose stems with a diluted version of the lime green, darkened later with some red. The leaves had lovely broad shapes, and some were painted with a cool blue green, others with a warm yellow green.

In painting the various pots, I kept all details soft and out of focus. Luckily, just where it was needed, the dark pot was next to the lightest flowers. It was made of black plastic and I interpreted it with French Ultramarine with Cadmium Red. I ran a wet brush around the base of the pot, allowing the colour to bleed out, thus keeping the edge soft in the shadow.

Finally, with restraint, I painted the shadows on the petunias. Some were cool and needed a Cobalt Blue; others were warm, echoing the yellow centres. A few more touches to the steps or a deeper dark somewhere might still be needed.

It is best to come away from the subject before adjusting the final tones. It is more important to judge what the painting now needs, rather than what was there, to achieve a harmonious balance.

Herbaceous Border

Herbaceous Border

(24 x 18in, 61 x 46cm)
OPPOSITE *The planned yet informal look of this herbaceous border, backed by the ancient converted barn, had great appeal for a painting.*
Colours used: *Cadmium Yellow Pale, Cadmium Yellow, Gamboge, Yellow Ochre, Permanent Rose, Permanent Magenta, Cadmium Red, Madder Brown, Cerulean Blue, Cobalt Blue and French Ultramarine Blue.*
Paper: *Arches 140lb/300gsm.*

*This painting is demonstrated in my video **Gardens in Watercolour**.*

Quite a long soliloquy took place while I decided on the composition for this painting (right). The ancient barn building was attractive but, were I to include it all, the flower bed would become too small a feature. From which angle did I want to work? The distant garden features were all delightful. I chose this composition finally because it enabled me to include part of the barn and to really enjoy the flowerbed. The view beyond was restful and did not compete with the herbaceous border. My first mark was the vertical of the barn building, the upward sweep of the roof line and the opening angle of the border bed. The invasion shape to the curved bed was then drawn in, and the stepped heights and groups of plants were planned and drawn simply. This helped me to keep the form of and some order in the bewildering display on view. The other details such as windows, chimney pots, far trees and garden table were sketched in and, as the day had only fitful sunshine, I made a note of the dappled shade on the lawn.

I painted a very wet wash across the barn, letting it run down, but I preserved the white of the later pink roses. The colour was a mixture of Cobalt Blue and Permanent Rose with a touch of Yellow Ochre. The textured slat marks were added later. The roof wash followed using Light Red, and the foundation greens for the

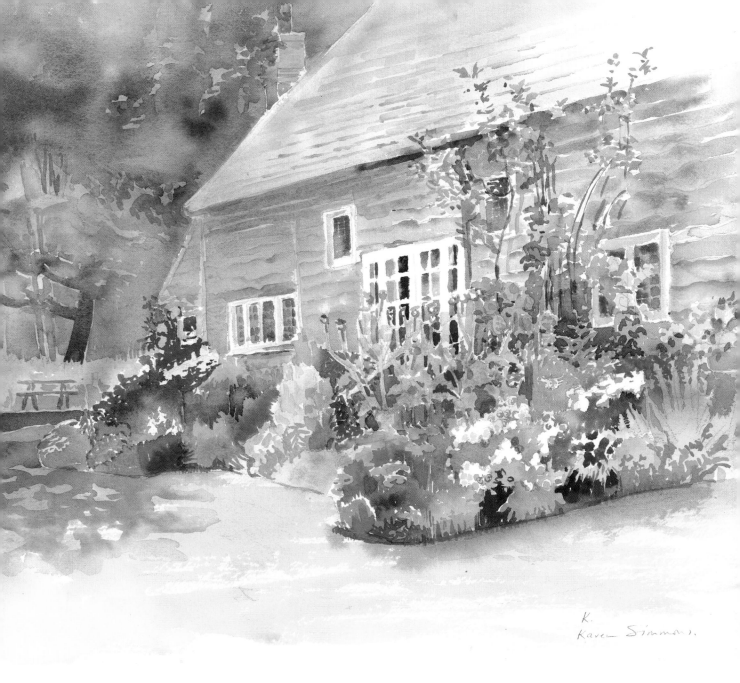

Karen Simmons.

trees were blushed in. This bled into the roof; which did not matter. When I
needed to deepen the tones for the trees, I was able to redefine the roof. French
Ultramarine Blue with Yellow Ochre were the colours I used for the trees because
they granulate, giving a textured effect.

For the herbaceous border I started at the far end with the bright red roses and
quickly added in the dark foliage below, allowing them to bleed together. The dark
blue green was also used to cut out the tall marguerites from the wash that had
been used for the barn. In front were some very pale pink flowers. To convey these
I left them white but put a pink background around them. I did the same for the
pale pink roses in the front bed. Other mounds of flowers were treated by some
colour blushes which were later defined with a darker tone behind.

The giant thistles had big turquoise grey leaves which were painted using
Cerulean Blue. In their space shapes, some deep blue delphiniums could be seen. I
used French Ultramarine Blue for these and for the blue in the front bed. Some

bright pink foxgloves were painted with Permanent Rose and Magenta combined. The yellows were blushed in, deepened with Gamboge in places, then overpainted with pink and red in others. The pink roses in front had a few more pink details added. The green lying over the pink blush went grey, so it was just right for the grey green of the rose leaves.

The lawn was brushed across with one sweep of Cadmium Yellow. Cobalt Blue with a trace of Yellow Ochre was used to edge the flower bed; this then bled forward to suggest some shadow in the grass. Last of all, with a wet brush, I looped around the lighter colour of the lawn, then darkened with French Ultramarine Blue and Cadmium Yellow to convey the dappled shadows.

Hotel Flower Beds
(15 x 11in, 38 x 27cm)

Drenched by a Greek sun, the stone-edged beds were vivid with colour. The little pollarded tree cast its shadow along the ground (one colour) and on to the wall (another colour). The foreground bed, centred with the graceful palm, was domed with geraniums.

On the sunny side I painted the geraniums and the leaves with Cadmium Yellow. I touched the underneath side of the flowers with Cadmium Red and the underneath side of the leaves with Cerulean Blue, letting the colours bleed together.

On the shadowed side, the flowers and leaves were starkly silhouetted against the sunny gravel beyond, so I used Cadmium Red with Permanent Rose for the geranium heads. The very dark green was made using French Ultramarine Blue, a trace of Cadmium Yellow and a minute amount of Cadmium Red. This was also used for the leaves and a slight variation of it for the palm. Shadows colours on the ground vary with the surface. Here they were a blue or red mauve over the warm gravel surface. On the white wall they showed blue.

To make a painting sing with colour and sunshine, we need to observe the different shadow colours.

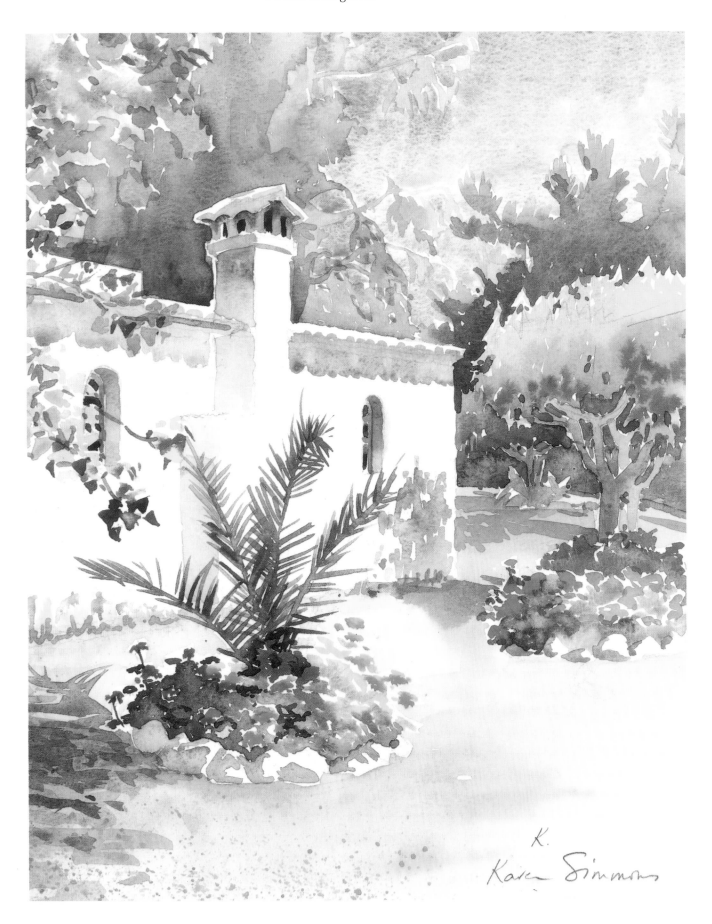

Still life with flowers

Flowers in a container or in a group of vases or pots provide a totally different type of subject from those growing wild or arranged on their own. The surface on which they are standing is part of the composition, and space and air need to be understood. The debate about when a subject should have a background or when a background can be left out is often raised. As a guide, a single flower or a botanical study need not have a background. Once you have a container on a base, i.e. the subject taking up space, a background does complete the composition. However, the artist is always free to decide what seems right for his or her work.

Flowers in a vase fall at angles very different from their own natural ones. They are most paintable when thrown into a vase and allowed to fall at will. An arrangement suitable for a living room is somehow less attractive to paint – perhaps because it is already a work of art. The composing of a group on your paper needs thought. A few sketches will identify what part of the whole interests you the most and where to place it. The peripheral blooms need to be painted as simply as possible, while texture and details can be shown in the focal area. Still life with flowers is a subject which is always available, whatever the time of year. You need not search far, the subjects are on our windowsills and tables, ready to hand.

The Orange Lily

In this painting, as in so many others, it helped to isolate the white. After I had plotted and boxed the various shapes I wet the whole paper with the exception of the group of marguerites and blushed some Aureolin into this area. I used this yellow to serrate the outer profile of the marguerite islands and let the colour disperse naturally. The very pale yellow then became the foundation for the other colours.

The curves of some of the silky orange petals of the lily had a pink sheen which I painted with a weak Permanent Rose, added Gamboge followed by some Cadmium Orange deepened further with Cadmium Red. I used Cadmium Red with Madder Brown for the pistil and the anther markings. The spotted markings are lost on the curves but show more clearly in the shadows. It is this change of colour and tone that describes the form.

After that I profiled the geranium with Permanent Rose and while it was still damp I shadowed it with Cadmium Red. I returned to the marguerites, painting in the yellow button. With a mixture of Cerulean Blue, Light Red and a hint of Aureolin I painted the grey leaves. For the slightly darker ones I changed from Cerulean Blue to Cobalt Blue and used less water.

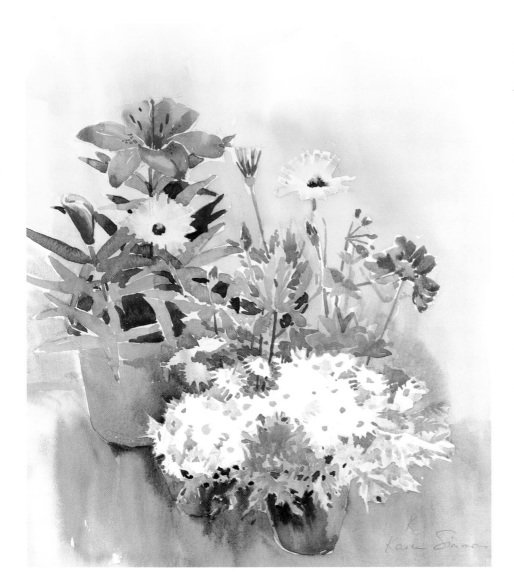

The Orange Lily

(18½ x 16in, 47 x 41cm)

The collection of pots was bought from a nursery to paint as a demonstration. I wished to show the effectiveness of shadowing a pink with red for the geranium and that by treating the white marguerites in groups or islands I could suggest a more powerful white. The curved petals of the big orange lily were highlighted with a pink sheen. I also wished to demonstrate that putting a yellow background behind a yellow flower could work.

Colours used: *Aureolin, Gamboge, Cadmium Orange, Cadmium Red, Permanent Rose, Light Red, Cobalt Blue, French Ultramarine Blue and Madder Brown.*

Paper: *Bockingford 140lb/300gsm*

Where the green met the white I could emphasize the petalled edges of the marguerites: a few extra darks were needed in places. With great restraint, I used a little Cobalt Blue for the shadow on the marguerites – it was important to leave a large area of untouched white.

I painted the lily leaves as simply as possible. The leaves crossed over each other making interesting space shapes and I darkened these with a rich mixture of Gamboge, French Ultramarine Blue and Cadmium Red. The tones of the leaves varied, some in the light, others in the shade, and the rigid stem was tinted with the orange red pigment. I re-wet the paper and dropped in some Gamboge with which I cut out the pale gerbera head. Further down the painting, the colour became green to blend in with the leaves. The foreground was a mixture of Light Red, Permanent Rose and French Ultramarine Blue. These colours were similar to the ones I had used for the pots, the colour and tone being shared in this area keeping the attention on the marguerites.

Summer Flowers

(20 x 22½in, 51 x 57cm)

This was a demonstration painting carried out in front of an audience of around 300 people in the Domaine Theatre at the New South Wales Art Gallery in Sydney. The theatre had raked seats as in a cinema, and a large cinema screen. The video cameraman followed every brush stroke, drip and bleed, and the painting came up on the screen for all to see. The microphone attached to me picked up everything I said as I described what I was doing. I may have been using watercolour but I felt I was painting with adrenalin!

I made a few plotting marks to make sure that the spread of flowers would fit. I then wet around the white gerberas to isolate them, spreading the water generously but not all over the paper. Inside the wet area I blushed some Cadmium Orange and Gamboge; the colour invaded the white petals where there were major gaps. I profiled the zinnias with a second layer of colour, Cadmium Orange and Cadmium Red, and established the profile of the orange zinnia to the left, ignoring individual petal markings. The upturning front petals, however, were suggested. By not texturing the light side, the golden orange could have more impact. The same flower had some petals which showed their grey undersides and for these I added some French Ultramarine Blue to the orange, allowing it to run down into the flower below which was strengthened with Madder Brown and Cadmium Red.

The tall gerberas at the back were more coral than orange and I painted the feathered heads as simply as possible using a mixture of diluted Permanent Rose and Cadmium Orange. The adjacent zinnia was a pinky mauve so Permanent Rose with Cerulean Blue were the main colours.

Instead of contrasting colours I chose like with like for the background washes. This method unifies the composition and implies more flowers, thus adding depth to the arrangement. I kept the yellow for the warmer side, thus giving it a sunny aspect. By having the complementary colours present in the painting – orange and blue, yellow and mauve, red and green – I could make the colours sing.

***Colours used:** Cadmium Orange, Cadmium Red, Gamboge, French Ulramarine Blue, Madder Brown, Permanent Rose, Cerulean Blue, Cadmium Yellow pale, Cobalt Blue,*
***Paper:** Bockingford 140lb/300gsm.*

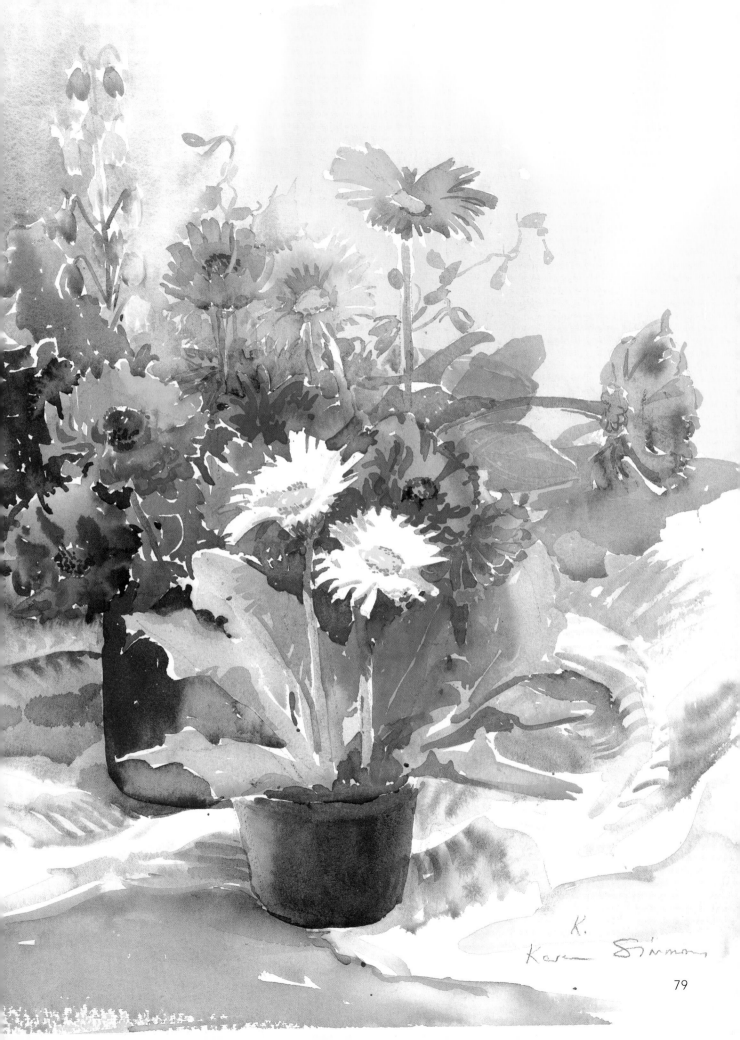

K.

Karen Simmons

Mother's Day
(16 x 20in, 41 x 51cm)

A group of flowers collected for a Mother-cum-Grandmother on Mother's Day made a colourful subject for painting. Anemones were her favourites, the cheerful yellow pansy was irresistible and I liked the fresh white cineraria with its blue-tipped petal. The tablecloth I arranged them on had stripes which echoed the flower colours (see diagram, page 17)

I clashed the anemones with pinks, oranges, reds, blues and purples as wetly as possible. The pansies were painted with two yellows, Cadmium Yellow Pale and Cadmium Yellow. The leaves directly behind their heads were painted with a yellow green to maintain the glow from the pansies, and I kept some of the cineraria heads white but muted several of the others with a tint of blue or green. The background was painted blue with blue and orange with red to unify the composition.

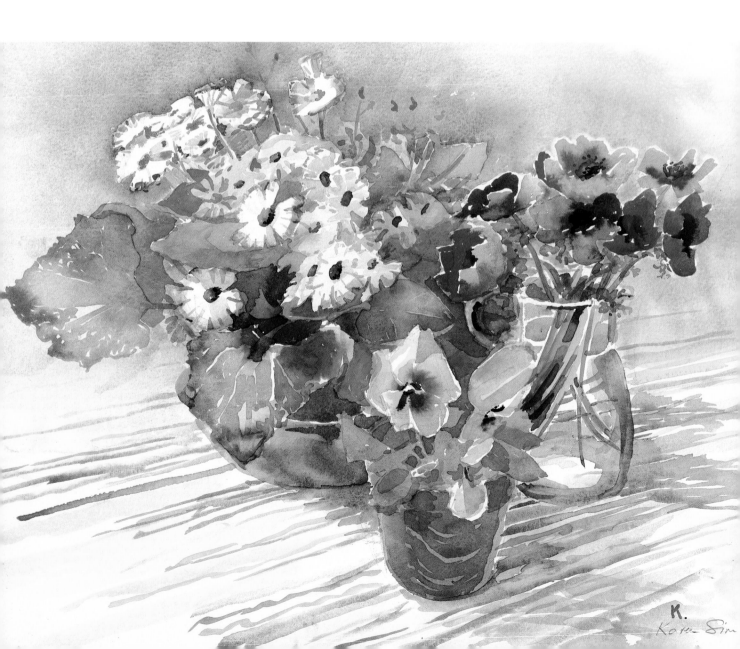

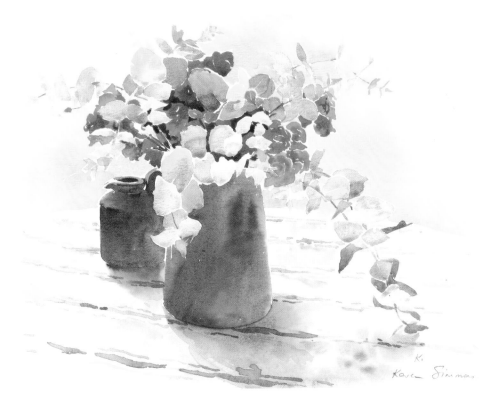

Green Jug

(12 x 15½in, 30.5 x 39.5cm)

The plain green jug had been placed on the table in a farm cottage we rented in Australia. It made us welcome and drew my eye. The blue gum leaves spilled out, red climbing roses tucked in amongst them, and the jug reflected their colours. The whole combination was an enticement to paint. I saw the other blue bronze jug on the window sill and placed it beside the green one.

Colours used: *Cadmium Yellow, Gamboge, Permanent Rose, Cadmium Red, Madder Brown, Raw Umber, Cerulean Blue, Cobalt Blue, French Ultramarine Blue and Hooker's Green.*
Paper: *Bockingford 140lb/300gsm.*

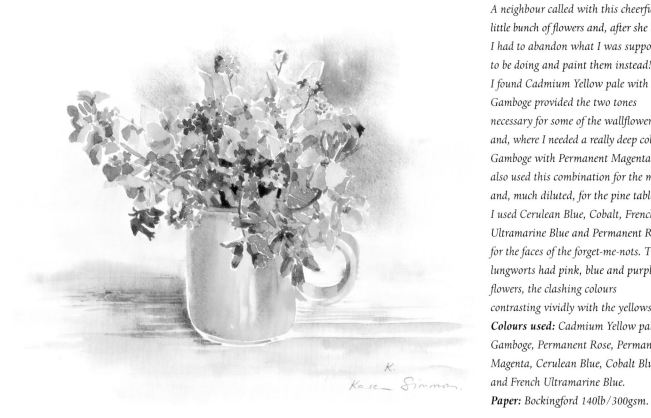

Yellow Mug

(11 x 13in, 28.5 x 33cm)

A neighbour called with this cheerful little bunch of flowers and, after she left, I had to abandon what I was supposed to be doing and paint them instead! I found Cadmium Yellow pale with Gamboge provided the two tones necessary for some of the wallflowers and, where I needed a really deep colour, Gamboge with Permanent Magenta. I also used this combination for the mug and, much diluted, for the pine table. I used Cerulean Blue, Cobalt, French Ultramarine Blue and Permanent Rose for the faces of the forget-me-nots. The lungworts had pink, blue and purple flowers, the clashing colours contrasting vividly with the yellows.

Colours used: *Cadmium Yellow pale, Gamboge, Permanent Rose, Permanent Magenta, Cerulean Blue, Cobalt Blue and French Ultramarine Blue.*
Paper: *Bockingford 140lb/300gsm.*

The Red Begonia

I did no preliminary pencil work for this, only mental planning, and started with clear pinks, oranges and reds laid next to each other on the white paper.

Permanent Rose was used where the light fell, and Cadmium Orange, sometimes with Gamboge, where the light shone through the petals. Cadmium Red on its own, or deepened with Permanent Magenta, was used for the darker petals, the different reds building the form. The begonia heads at the back were painted more simply.

A single layer of red was laid and, when dry, was given a few lines with the darker red. The leaves were not textured but their shapes were respected. For the top-lit leaves I used Cobalt Blue with only a little Gamboge and for the richer green leaves French Ultramarine Blue with Gamboge. I included some Cadmium Red for the intense dark.

I painted the African Violets with Permanent Magenta and French Ultramarine Blue, leaving the tiny yellow centres, and greyed the leaves by adding a very small amount of the purple into the prepared green mixture. The dramatic blue pot had reflections from the table-cloth on its sides. I attempted to convey this by painting the pot first with Cerulean Blue on the corner, and then with French Ultramarine Blue into which a trace of Permanent Rose had been mixed. While this was damp, I criss-crossed with Permanent Magenta. The clashing of blues made the pot a lively colour.

The little pot in front was painted with a mixture of Light Red and Permanent Magenta. A weaker, quieter mix of French Ultramarine Blue and Permanent Rose was used for the pot behind. When the yellow wash was added, the pot was still damp and so the colour bled into it. This had the happy effect of suggesting some reflections. After this, I laid the red checks over the yellow, the darker red and squares of blue indicating the shadows.

A few white marguerites were kept white and dry as I prepared the background with lots of water. Then Cobalt Blue was allowed in and spread to fuse with the yellow. When this was dry, I repeated the process to cut out the pale blue marguerites by deepening the blue behind them.

I spangled the marguerites with the yellow centres. In order to suggest the dainty blue-grey foliage, I scribbled some cool green, then dropped a stronger tone in and let that travel along the scribbled shapes. Then I darkened behind one or two leaves and stems. At the end I felt quite drained from all the concentration and excitement.

The Red Begonia

(20 x 16in, 51 x 41cm)

OPPOSITE In this painting I really wanted the colours to go 'Pow!' Maximum clash with clear vibrant paint! Note the different treatment between the begonias in the front of the blue pot and those at the back. The African violets were the same colour as the deep blue pot so they were encouraged to melt together. The spindly marguerites in the background made it cool and airy, and the table-cloth was garish with red and white checks. It was a good excuse to enjoy colour to the full.

Colours used: *Gamboge, Cadmium Orange, Cadmium Red, Permanent Rose, Permanent Magenta, Light Red, Cerulean Blue, Cobalt Blue and French Ultramarine Blue.*

Paper: *Bockingford 140lb/300gsm.*

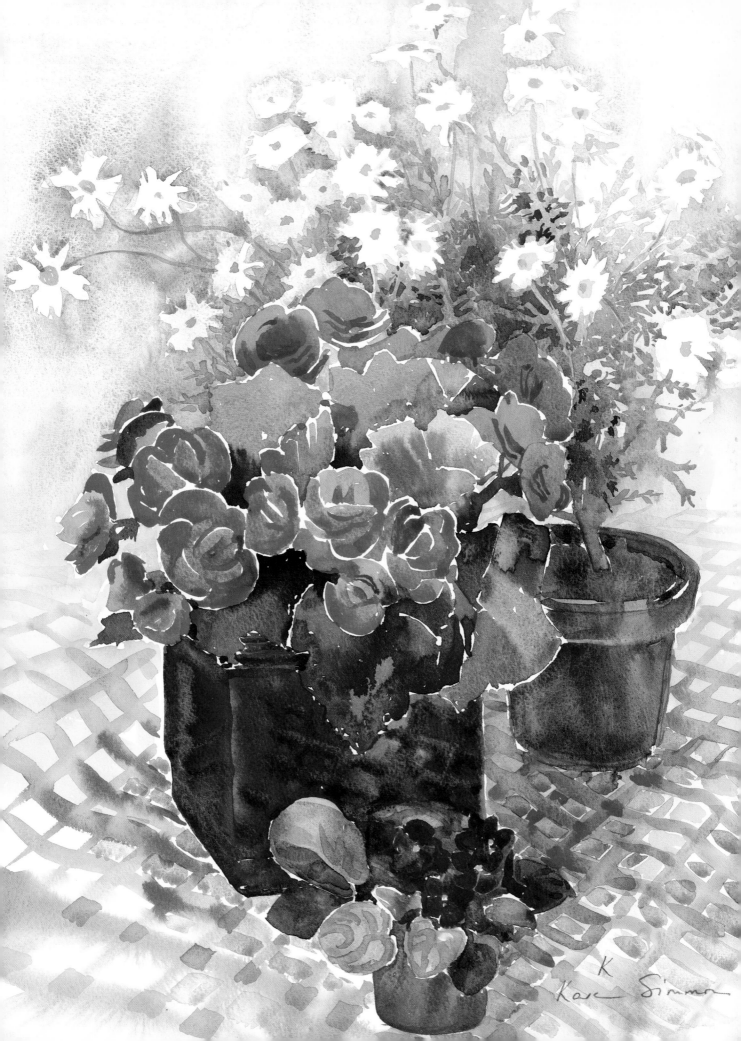

The Yellow Teapot

The Yellow Teapot

(21 x 18in, 53 x 46cm)
OVERLEAF I had often thought that
dishes abandoned on a table after a
meal could make a wonderful
painting subject. A while ago I was
called away from the breakfast table
and on my return saw this scene as a
'must'. As soon as I was able to give
the problem some time, I reassembled
the breakfast teapot and mugs with
some sweet peas and the tall
patterned jug which were already on
the table.
I tried out a possible composition
horizontally, and from a standing
viewpoint. I particularly liked the
rhythm coming through from the
back in curved steps leading to the
used paper napkin. Then I tried the
composition vertically (see opposite),
sitting on a stool for a crowded
viewpoint. I liked that composition
better and roughly shaded in the
tones to see how it would look as a
painting. Before painting, I moved
the left plate inwards and added
some crusty bread and a nectarine.
Colours used: *Cadmium Yellow pale,*
Cadmium Yellow, Gamboge, Yellow
Ochre, Light Red, Cadmium Red,
Permanent Rose, Permanent
Magenta, Madder Brown, Raw
Umber, Cerulean Blue, Cobalt Blue
and French Ultramarine Blue.
Paper: *Arches 140lb/300gsm*

This painting is demonstrated in my
video At Home with Watercolour.

Composition sketch

I drew the various objects on the table, taking care of the space shapes between them. When faced with a curved shape such as that of the teapot and the jug behind, I draw a vertical line through the middle. This helps to keep the curves in balance. Before starting to paint I rocked the eraser over the drawing lines to lift off any surplus lead.

At last I could get into colour! With a brushful of diluted Cadmium Yellow Pale I isolated the highlights on the teapot and added Gamboge and Light Red to deepen the colour. I did the same for the yellow mugs.

The teapot spout needed to be darker still. I kept the Gamboge and Light Red mixture dense and added just the tip of the brush into French Ultramarine Blue as the darker colour had a greenish tinge. The little jug had a pronounced greenish tinge reflecting the blue paper napkin. The plates and the diary were reflected in the mugs. At first I left these white, but, later when all was dry, I glazed over them to tone them down. What did I tone them down with? I toned them down with a dirty puddle of colours mixed on my palette.

I found the yellow and the colour of the stone jar behind the teapot lid particularly pleasing, and described it with Cobalt Blue and a touch of Permanent Rose mixed with Raw Umber. I also used some of this mixture, but with more Cobalt Blue, for the glass of the marmalade jar, leaving white areas as highlights. I used Gamboge and Light Red for the marmalade, keeping it paler at the bottom where the light was coming through the marmalade. I also painted the newspaper reflection on the side of the jar with a mauvey grey. Later, using Light Red and Permanent Magenta, I scattered in the thicker peel that showed in the marmalade.

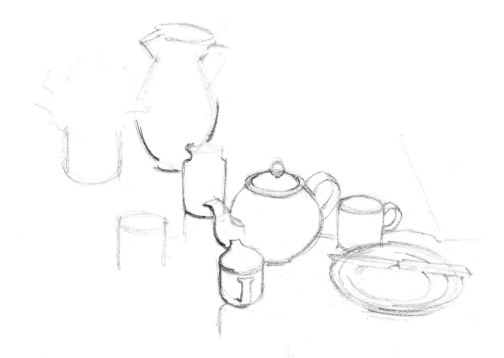

84

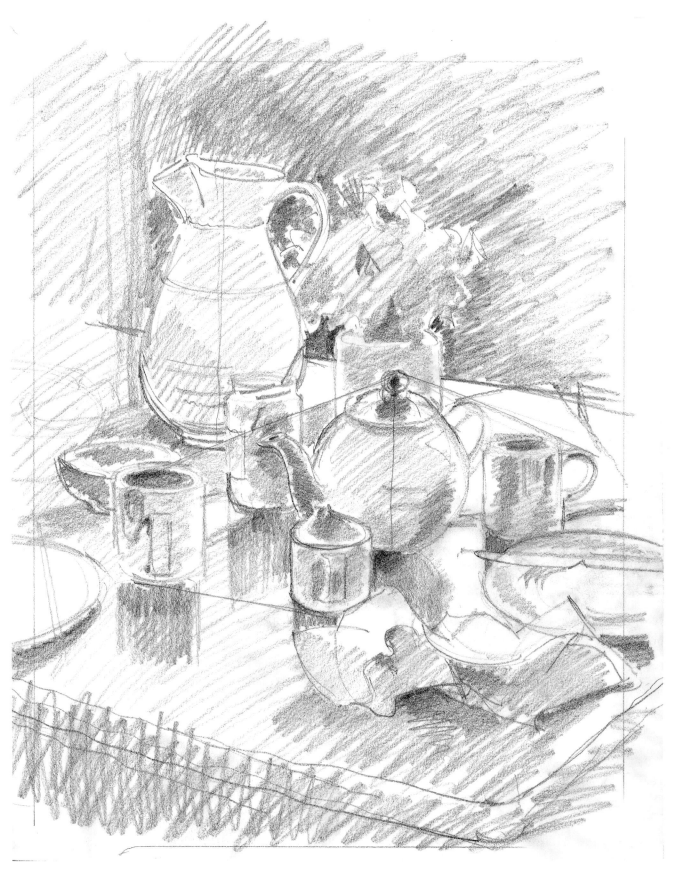

Tonal sketch

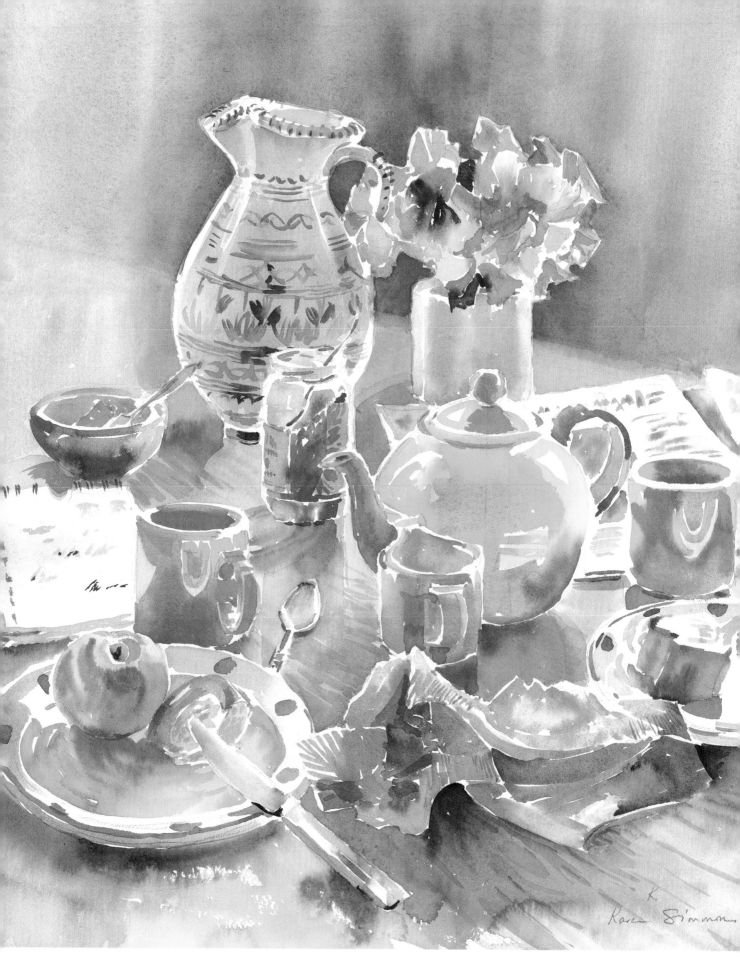

The plate on the right with the crusty bread gleamed white, showing a little colour only in the shadow. The bread was painted with Gamboge, Light Red and a little of the dark Madder Brown.

The plate on the left held the nectarine, some bread and a knife. The nectarine was highlighted with dilute Permanent Rose running into some Gamboge; I deepened this with the same two colours but less water. The stainless steel knife reflected the blue napkin, and the plate was painted with Gamboge deepened in shadow with Light Red, the spots on both plates with Cobalt Blue, weak and strong.

The crumpled napkin was a delightful combination of blues, pale on the top layer; I used Cerulean and Cobalt Blue for this, and the same colours, more densely mixed, for the inside. I made the emerald green by adding some Cadmium Yellow pale to the mixture, and painted the darker blues with French Ultramarine Blue plus Permanent Rose.

Before attempting the pattern on the tall jug, I painted the warm and cold shadows on it first, as if it had been a white jug – 'Volume before texture or pattern!' While this was drying, I painted the sweet peas.

These were not the centre of attraction so they were painted very simply. I took care of the profile shapes but let the colours bleed together to keep them soft and out of focus. I used Permanent Rose and Magenta plus Cadmium Red, then Permanent Magenta with French Ultramarine for the strong purples. Using the same colours for the pattern on the jug, I was careful to vary the tone, light on the light side and stronger where the shadow was deepest.

The pine table picked up the light, the reflections and the shadows, and this added to the interest. I washed in some diluted Light Red, cooling it with Cobalt Blue towards the back and warming it with Yellow Ochre at the front.

The shadows were added while this was damp. Permanent Magenta, mixed with only a little blue, was dropped into the Yellow Ochre. This made a warm shadow colour. I added more French Ultramarine in places as well as Madder Brown where extra darks were needed. The reflections were painted in quite gently when the table was dry. The newspaper and diary details were just suggested.

The background needed to be plain and of a strong tone. I wet the area generously, taking the brush below the table line. I used Permanent Magenta, Cobalt Blue and some Gamboge to make the varied colours for the background and let the colours run down to the table, making a soft join. I could deepen the tone while it was still wet. I also tilted the board to encourage the pigment to travel.

One is in no fit state at the end of a painting to judge the work. Most artists put the work up in the house, choosing a frequented area. Catching sight of your work unexpectedly is likely to draw your attention to any detail that might need correcting.

The Yellow Teapot
(21 x 18in, 53 x 46cm)

Roses

Roses are a joy – both in the garden and in the home – but to paint them is more agony than ecstasy! It is easy to lose the shape of the rose with all those petals, and their texture can distract from the more important objective, which is to portray the rose as a three-dimensional sculpture.

The plotting and boxing approach helps to achieve the overall proportion and perspective of the rose. With half-closed eyes, you will note that petal details will be bleached by a strong light, becoming nearly invisible. Separate petals are more visible in the mid tones, but in the shadow area they may melt together again. Roses are tough survivors, enduring quite hard climates and conditions. Their stems may be fairly thick, angled or straight or, less frequently, curved.

The leaf shape varies between different types of roses. The pigment of the rose will usually appear in the leaf and the stem. More important than texture are the angles and junctions of the stems and the shape of the leaves. The design of the rose is certainly worthy of respect.

A Tapestry of Roses

The pale rose called Ginger Ice looked perfect, and I chose it to start the painting. I worked outdoors where I could observe the rose in natural light.

Once I had boxed the head, I drew the main overlapping petals. A watery Permanent Rose was painted over the whole head, just faintly stronger on the right side. With Cerulean Blue and Permanent Rose I shadowed the cool outward-facing petals. While it was still damp, I dropped in a little Gamboge near the centre and as soon as all was dry I mixed Gamboge with a little Permanent Rose for the golden intervals in the heart of the rose. By adding more Permanent Rose to the Gamboge I had coral red with which to paint the interior colour. This was visible only when the petal lifted its skirt.

In places, I painted in some very delicate shadows, but on the light side I ignored them. A small insect nestled in the duvet of petals. I painted him in, too. The bud alongside was more vivid, but the colours were essentially the same. I painted the stems of both rose and bud, tinting the green with some of the coral red.

The next rose was Royal William, a deep red rose with mitred petals. It was partially screened by the unopened bud and tinted leaves in front. I painted these first, and seemed to need all sorts of colours. Cerulean Blue with a little Gamboge made the foundation green and there was a mauvey sheen on some of the leaves. I used Permanent Rose with a touch of the blue for these.

A Tapestry of Roses

(20 x 16in, 51 x 41cm)

OPPOSITE I had in mind a selection of large roses for one of the pages in this book, but then I was seduced into adding the small-faced rosa rubrifolia as well. As a result, this painting took several days to build. I painted the four big roses first, and then added the rosa rubrifolia, putting in the background last.

Colours used: *Aureolin, Gamboge, Cerulean Blue, Cobalt Blue and French Ultramarine Blue.*

Paper: *Bockingford 140lb/300gsm.*

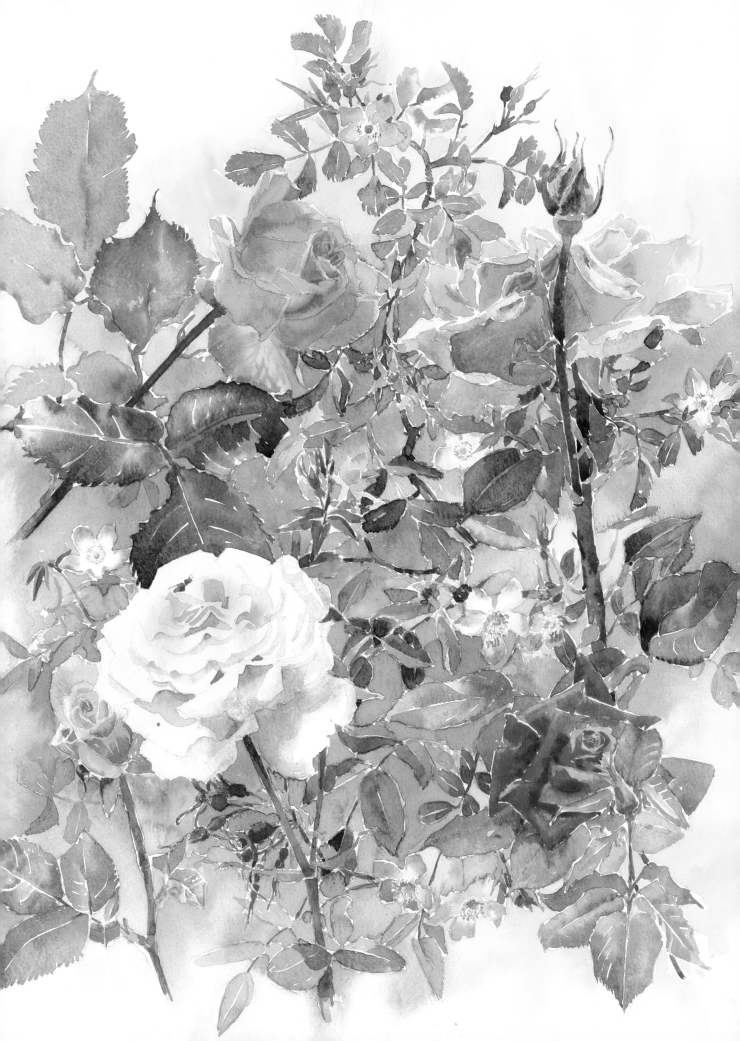

The more mature leaves had scarlet lines and edges to them. The dark red rose was painted with Permanent Rose, and Gamboge undercoated the Cadmium Red. The very dark red was made with Cadmium Red and Permanent Magenta.

The brash, flame-coloured rose called Whisky Mac was next. I chose it because the leaves were so magnificent. The rose was against the light so all but the topmost edge was painted with Gamboge. I mixed more Gamboge with Cadmium Red for the deeper oranges and dense Cadmium Red for the inner crevices.

The leaves were glossy enough to pick up a blue sheen, for which Cobalt Blue was used. Still using Cobalt Blue but adding Gamboge, a warmer green was made and dropped in to fuse gently with the blue. French Ultramarine Blue with the same Gamboge made the rich dark green. The red stems and central vein was painted with Cadmium Red, which also embroidered the edges of the leaves.

The leaf behind glowed with the light coming through it and I painted it with rich Gamboge and a nudge of green and tipped it again with red. The big leaves behind were treated with an almost grey colour to help them recede.

I liked the back view of the big Peace rose with the bud thrusting past. It was like a youngster springing up when one's back is turned! The top curled petals caught the down light and were painted with the cool Permanent Rose. In contrast, a rich Gamboge glowed through some of the petals, while others, overlapping, showed red. The lower outer petal was painted with Gamboge to which a diluted Permanent Magenta had been added. The stem was painted with a dense Madder Brown turning to a muddy green lower down. The bud, dark against the light, was a warm red; the sepals, curling like flames, were tinted with Permanent Magenta.

I now wanted to weave in the little pink flowers and purple red leaves of the *rosa rubrifolia*. This proved an intricate undertaking. I painted the visible sprays, adding another one or two each day. The leaves were especially attractive in their colouring. I used a green made with Cobalt Blue with a tiny amount of yellow, and added Permanent Magenta to this, making a purpley grey. With minor variations, it seemed to describe the leaf colour quite well.

The background now had to be worked in around all this confusion. I decided to start with the perimeter area. I wet patiently from roses to the edge of the paper and blushed in yellow, grey, yellow, blues, back to yellow again – going clockwise around the painting. Then I had to wet the tiny spaces in between and match up the colours. This took a long time. Once the background was completed, I needed to darken one or two leaves and stems. Then at last I could lay down the brush.

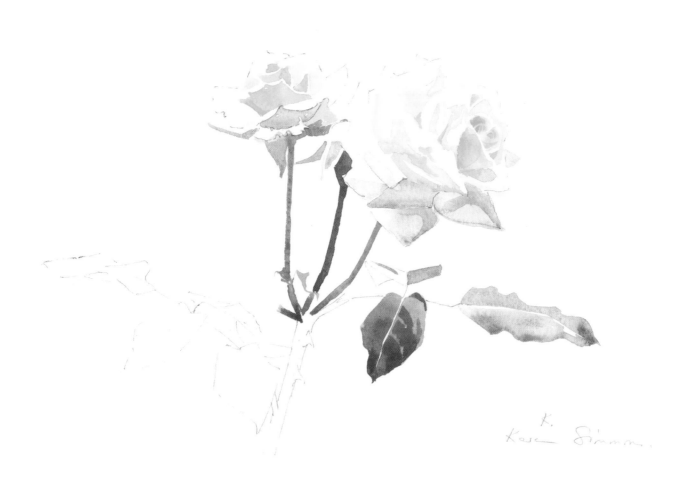

Swan Lake
(12 x 14in, 30.5 x 35.5cm)

This beautiful rose is aptly named after the ballet for it holds itself with the grace of
a ballerina. The colour is of such a pale pink as to be almost white and it is only in
the depth of the rose that the colour is sufficiently amplified to show the shell-like
pinks. I drew the roses with the boxing method and erased the lines later. The
leaves stretched out either side with such poise that I enjoyed drawing them. The
painting was interrupted so I decided to leave the work unfinished.

Hips and Roses

Stage 1 illustrates the early stages of *Hips and Roses in a Glass*. I first boxed the overall shape, which helped me decide where and how to place it. The arrangement of roses and hips in the glass was wider than it was tall, but I also had some foreground interest, which I needed to plan for. Once the composition had been decided, I boxed the facing rose. The leaves were drawn with crisp angular lines, which would soften when painted. Drawing a leaf this way shows you where it is widest and its shape at the point.

When I drew the glass, I took note of the distance between the lowest petal and the base of the glass. I drew the hips, watching for the space shapes, and also the other roses and the lovely white bud. Now I was ready to paint.

I prepared the facing rose by painting its shape with a full wet brush, but left a few of the petals white and dry. I blushed some pale Permanent Rose into this wet area for the outside petals. Gamboge was added for the centre and for the lower shadowed side. I deepened the centre with more Gamboge.

Stage 1

Stage 2

The two other peach roses were prepared in the same way but the white bud was painted petal by petal, some shadowed with blue, others with a warm greeny yellow. I kept part of a petal and some of the edges white.

The next stage was undercoating the leaves. Where there was a blue sheen I undercoated with diluted Cobalt Blue, and where the light shone through the leaf I undercoated with Cadmium Yellow. Later I painted over the leaves with a deeper green, using Cadmium Yellow and French Ultramarine Blue. I prepared the hips with Gamboge leaving white highlights, and painted a few of the greeny yellow leaves into the glass and some of the stems.

If you need a good bright red, undercoat with a yellow; the red will then stay bright and lively. Cadmium Red on its own, on white paper, will be a disappointment when dry.

To interpret glass or any shiny surface, just accept and obey what you see and you will have a success.

In Stage 2 (above), I returned to the leaves, darkening some, and re-wetting and

softening the highlights in others. In the top one, I painted between the veins, allowing the yellow to come through, and painted the deeper red over the yellow undercoat on the hips, retaining the highlights. I glazed some more colour on to the facing rose and while this was still damp enriched the centre with a combination of Gamboge and Cadmium Red. Before the glaze had dried, I softly defined a few of the near petals.

To glaze over a layer of colour can be very effective; it is possible in watercolour. The first layer needs to be completely dry, and the second colour should be painted by keeping the brush moving in one direction only, not backwards and forwards. In that way the undercolour is not disturbed.

I tackled the foreground with reflection and shadow by wetting only the paper, keeping the shaft of light dry, and blushing some yellows, a little blue, and then a grey into this wet area. The grey was made with Permanent Rose and Cobalt Blue muted with a touch of green, and I used the stronger mauve combination for the extra tone near the glass. I prepared the background with water, wetting from the subject to the edge of the paper, dropping the colours in close to the roses and hips and allowing them to drift away.

At its best, watercolour should look spontaneous, with no visible signs of hesitation or alteration. This is achieved with premeditation, inspiration and perspiration.

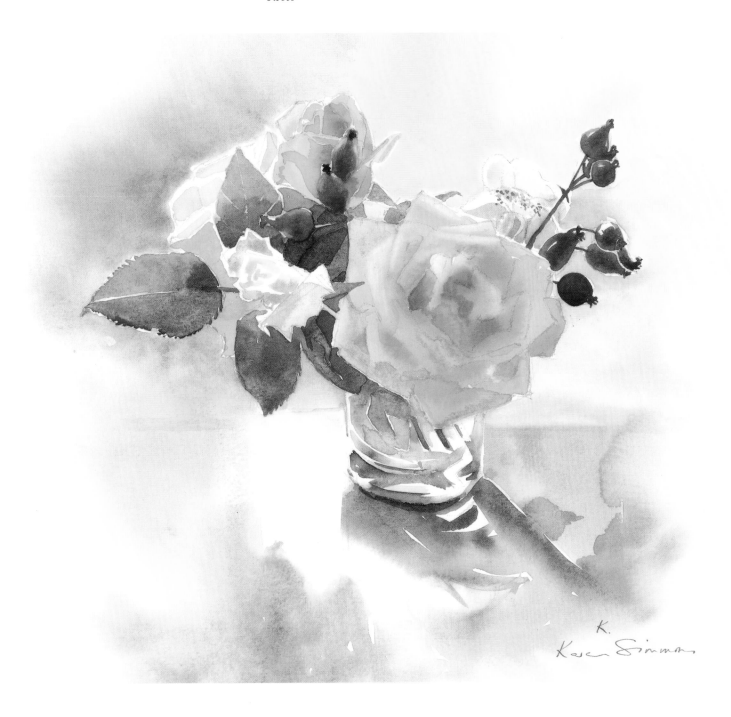

Hips and Roses in a Glass

(12½ x 14in, 31 x 36cm)

Colours used: *Cadmium Yellow, Cadmium Yellow pale, Gamboge, Cadmium Red, Permanent Rose, Cobalt Blue and French Ultramarine Blue.*

Paper: *Bockingford 140lb/300gsm.*

Interiors

Interiors that happen to have flowers can be an endless source of inspiration and most of us enjoy having flowers and plants in the home. Flowers set in an interior, on or against familiar objects and furniture, make an interesting combination of natural and man-made shapes. The bright daylight of a conservatory or the light on a window sill can be exciting, while interiors by lamplight have an altogether different mood, tone and colouring. All manner of possible paintings are around you in the home, waiting for you to 'see' them.

The Conservatory

A unifying wash or blush was not appropriate because this scene sparkled with light and colour. I decided to start with the flowers on the slatted bench. There were three sorts of geranium – a pink, a coral and a deep red – and they provided a cheerful clash of colour.

I used diluted Permanent Rose with a little Permanent Magenta for the pink geraniums, and Permanent Rose for the light domes of the others.

The coral-coloured ones were touched with Gamboge, the deeper red ones with Gamboge touched with Cadmium Red. The sun shone through the geranium leaves, so I used a glowing Gamboge with a little Cobalt Blue, and a denser, less yellow mixture for the shadows underneath.

Behind one of the big pink geranium heads was a dark-leaved stephanotis in a square blue pot which I painted with Cobalt Blue for the pale reflections and darkened with French Ultramarine Blue. Beside it, in a patterned pot, was a magenta bougainvillaea and I painted this pot in a soft mixture of Raw Umber and Cobalt Blue, to indicate that it was in shadow, before painting the floral pattern.

Having established the bright flowers, I painted the white chair and striped cushion, the chair picking up a number of coloured reflections, notably the pink from the red and blue cushion. In the full sun the stripes were a paler colour, the stronger red and blue being visible in the shadow.

On the floor in front was a large begonia in a terracotta pot. The sun was shining through some of the big leaves turning them a glowing carnelian red. I made these reds with Gamboge, Cadmium Red and Permanent Magenta, and painted the cooler green leaves with Cobalt Blue plus a little Gamboge. I used Light Red with Permanent Magenta for the terracotta pot. In preparation for the shadows, I had painted the floor at an earlier stage, using pale raw Umber warmed with a little Yellow Ochre, and leaving the join lines white.

The Conservatory
(24 x 18in, 61 x 46cm)
OPPOSITE I love my conservatory. I love its light, and I enjoy being there whether for work or relaxation. On a grey day it is pleasant, and when the sun streams in there is an abundance of light, colour and fascinating shadows. Outside the conservatory is a laburnum tree, and I wanted to paint this scene while the tree was in its full glory. I plotted, planned and drew most of one day, but the next day was grey. Alas, no shadows! Day after day was frustratingly the same, but finally the sun shone again and I could paint! But the laburnum had almost finished its brief glory.
Colours used: *Cadmium Yellow pale, Cadmium Yellow, Gamboge, Yellow Ochre, Permanent Rose, Permanent Magenta, Cadmium Red, Light Red, Raw Umber, Madder Brown, Cobalt Blue and French Ultramarine Blue.*
Paper: *Arches 140lb/300gsm.*

Karen Simmons

I painted the shadows as soon as they were at the angle I had been waiting for. For the shadow flowing forward from the begonia, I used French Ultramarine Blue, partially mixed with Permanent Magenta, some Yellow Ochre, and even a touch of Gamboge. The shadow from the chair was a similar mix but with less Magenta, while those cast by the slatted bench were painted with Cobalt Blue, a little Permanent Magenta and some Yellow Ochre.

The window frames were side lit, but otherwise mostly in shadow, and the white woodwork reflected the colours from the plants. It is these colour echoes that convey the sunshine and light in a painting.

I painted the feathery palm, observing the cold down light on some of the fronds: the blue contrasted with the yellow and darker greens behind. The view through the windows was painted pane by pane, and I wet each pane before painting the appropriate patch of colour. This had the effect of keeping the laburnum and the garden beyond out of focus. Although I was building this painting bit by bit, I needed to keep the balance of the whole in mind all the way through.

Family Photographs

I planned this composition with some care: the heavy lamp in line with the table's pedestal, both lying off-centre, the vase placed well to the left with the flowers and leaves reaching across the lamp, and the photograph frames as they normally were with a couple of books. I placed a patterned rug over the plain carpet to provide some interest below the table.

I needed a warm foundation colour for this subject, so I flooded the whole paper with water, and then blushed in a mixture of Cadmium Yellow and Gamboge. I put my brush down, and tilted my board until the yellow had diluted and dispersed. While the paper was still damp, I painted the glowing lampshade with Gamboge and some Cadmium Red. This had the desired effect of the colour creeping over the drawing line.

The lamp base was white porcelain, which reflected the warm light above and the cooler shadow below. When the lamp was reliably dry, I painted the flowers, some semi-translucent, others dark against the light. Textural detail was lost, but the serrated profile of the carnations made them easy to identify. I used Permanent Rose over the underlying Gamboge, as well as some additional Cadmium Red with a few Permanent Magenta accents.

I painted the dark, dramatic red tulips with Gamboge and Cadmium Red darkened with Permanent Magenta and the dark leaves and fern with French Ultramarine Blue, Gamboge and some Cadmium Red. The glass vase was amethyst in colouring, a great favourite of mine, and the light from the lamp lit the vase, showing the stems and making a beautiful reflection on the table. I painted the vase with well-diluted Cerulean Blue and Permanent Magenta with a touch of Gamboge and red at the base. Some stems were painted while this was damp, others were defined when the colour was dry. The reflection was painted with similar colours.

Family Photographs

(24 x 18in, 61 x 46cm)

OPPOSITE I had planned to paint this for some time. Often I had looked across the room and seen the flowers almost silhouetted against the lamplight – the pool of light, spilling on to the polished table, touching photograph frames and books. I thought it would be a lovely subject to paint. So, on an otherwise gloomy day, I did.

Colours used: *Cadmium Yellow, Gamboge, Yellow Ochre, Permanent Rose, Permanent Magenta, Cadmium Red, Light Red, Cerulean Blue, Cobalt Blue, French Ultramarine Blue, Raw Umber and Madder Brown.*

Paper: *Arches 140lb/300gsm.*

I used a palette of Yellow Ochre, Light Red, Raw Umber, Cadmium Red and Madder Brown for the gilt baroque photograph frame, each fern and curl picking up different lights and shadows, and Yellow Ochre touched while wet with Madder Brown for the little gilt frame holding the photograph of my daughter and grand-daughter.

The table already tinted by the first blush now had some stronger colours laid over it to describe the reflection, and outside the perimeter of the lamp the colour was cooler. I mixed Permanent Magenta with a little French Ultramarine Blue for this and laid it over the yellow foundation. I used the same mixture for the background. The front ledge of the table and the pedestal were so strongly silhouetted that there was no separate definition between them. I used blue, magenta and red to make the dramatic dark.

I washed the carpet first with Gamboge, then with Permanent Magenta for the shadow circle and while this was damp quickly suggested the carpet pattern – lighter colours for the light, darker colours for the dark – to maintain the appearance of shadow on carpet.

The Dresser

The Dresser

(22 x 18in, 56 x 47cm)
OPPOSITE A dresser by lamplight, with familiar, everday items in and on it, epitomises a home. Those of my children who live abroad always think of the kitchen when they think of home – the family gathering, the preparing and sharing of meals. To reflect this mood of enduring stability I chose a composition which is a multitude of Golden Sections (see page 16). Many artists have used this device, notably Piero della Francesca and Vermeer. This grid creates a mood of order and calm.
Colours used: *Cadmium Yellow pale, Raw Sienna, Yellow Ochre, Cadmium Orange, Raw Umber, Madder Brown, Cerulean Blue and French Ultramarine Blue.*
Paper: *Arches 200lb/425 gsm.*

This painting took several evenings to build. I worked out the composition on paper until I had what I wanted and traced it on to Arches paper. This saved me from making alterations on the precious surface of the watercolour paper.

I painted the flowers first, their colours harmonizing so pleasingly with the dresser. I used Raw Sienna with some diluted Light Red for the glass jug, kept a little untouched paper for the highlights on the glass and on some of the white lily petals, and painted the apples with Cadmium Yellow Pale plus a hint of Raw Umber – a combination which produces a lime green. Then it was Yellow Ochre and Light Red with a touch of Madder Brown for the russet pear, similar colours for the big candle, and French Ultramarine Blue blackened with Cadmium Red for the ironwork candlestick.

Next I washed over the entire painting with Raw Sienna and Light Red, let this dry, and painted a few of the wood grain marks, varying the tone, light in the light, darker in the dark. I used Permanent Magenta and French Ultramarine Blue tempered with a little Light Red for the glass panels and the glasses and, after I completed the blue plate and bread board in the alcove, I painted the background with a full brush of French Ultramarine Blue and Madder Brown. I was very tempted to paint the wheelback chair a darker tone.

I half closed my eyes to test the tone and decided to obey what I saw. I did keep it light and was glad I had; otherwise the lamplight effect would have been lost. I mixed a large puddle of French Ultramarine Blue and Permanent Magenta to paint in the delicate shadows thrown by the chair back and by the flowers. A stronger mix with some additional Raw Sienna was glazed over the upper part of the dresser that was in shadow.

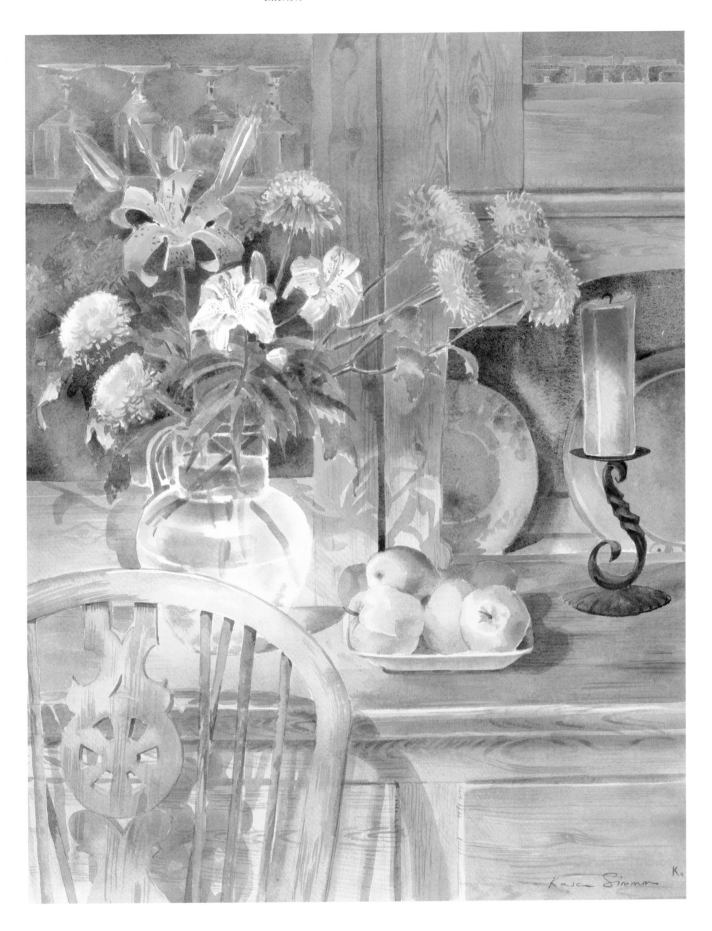

The Advent Wreath

(15 x 19in, 39 x 49cm)

Every year I make a wreath and light one candle on the first Sunday in Advent. With this one I liked the way the glossy red ribbon coiled and hooped over the greenery. The candles were painted in while the background was still damp; I wanted the edges to blur in order to convey the soft light from the candle flame.

Colours used: *Cadmium Yellow, Raw Sienna, Gamboge, Permanent Rose, Cadmium Red, Madder Brown, Cobalt Blue and French Ultramarine Blue.*

Paper: *Bockingford 140lb/300gsm.*

Sources and aspects

In this chapter, I describe flowers that were, at time of painting, unusual and strange to me, as well as some interesting aspects and viewpoints. Unexpected viewpoints, seeds and magnified details, are rich veins of inspiration for artists and designers.

Man has always used his natural surroundings as sources of inspiration and design. Images from nature have embellished tools and utensils. The Egyptians used designs derived from the lotus bud and the papyrus plant, and the Greeks used acanthus leaves. Byzantine, Celtic and Islamic art have all reflected this response to nature, and baroque art and art nouveau have entered our homes, with decorated mirrors, furniture, even drawer handles and, of course, jewellery.

Australian Plants

In the painting overleaf I have painted a few of the amazing plants to be found in Australia. The flowers are utterly different from those we are accustomed to in western Europe. One could paint for many lifetimes and not exhaust the wealth of flowers and plants indigenous to that country.

At the bottom of this painting are two Banksias – the pink one is from Western Australia, the yellow one, I believe, is the most common. Apart from their colour, their leaves are different. I painted the yellow one head on as the layered leaf ruff had amazing zig zag cut leaves. The leaves were thick and tough, the flower cones slightly furry. The tall needle-leafed plant was known as dragon's eye – mauve domed clusters open into white fluff balls, each with a dark centre which looks like a pair of eyes. Sadly, I did not observe it at that stage. I found the eucalyptus (blue gum) a lovely plant to paint, with fascinating rounded leaves and beautiful blue and blue grey tones.

Kangaroo paw grows wild but it is also cultivated. Here I have painted a yellow one and a finer red one. If you look closely at the flower clusters you can see the paws.

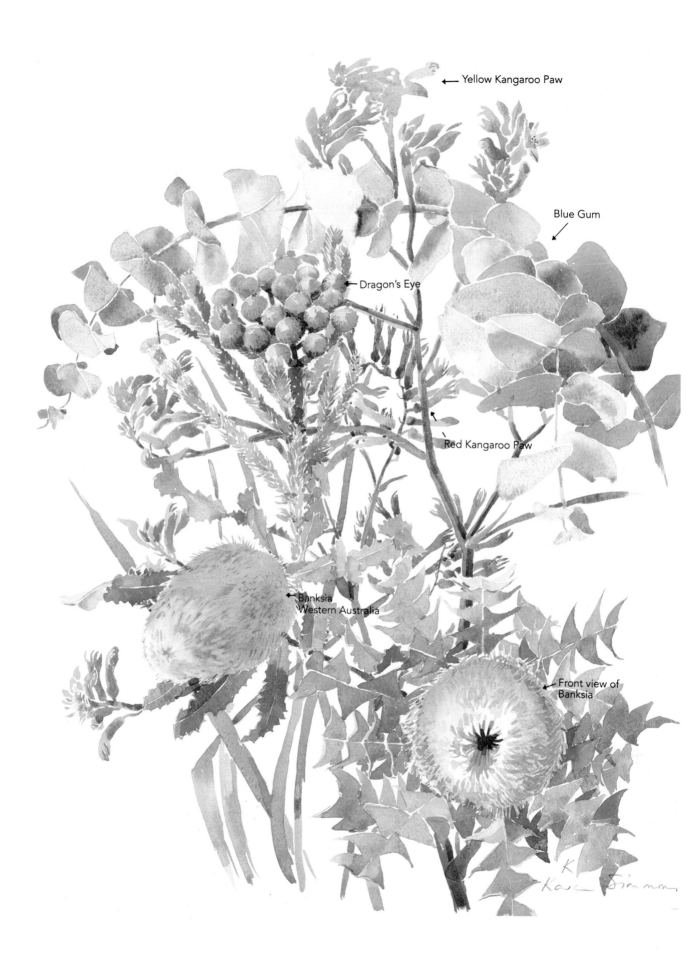

Yellow Kangaroo Paw

Blue Gum

Dragon's Eye

Red Kangaroo Paw

Banksia
Western Australia

Front view of
Banksia

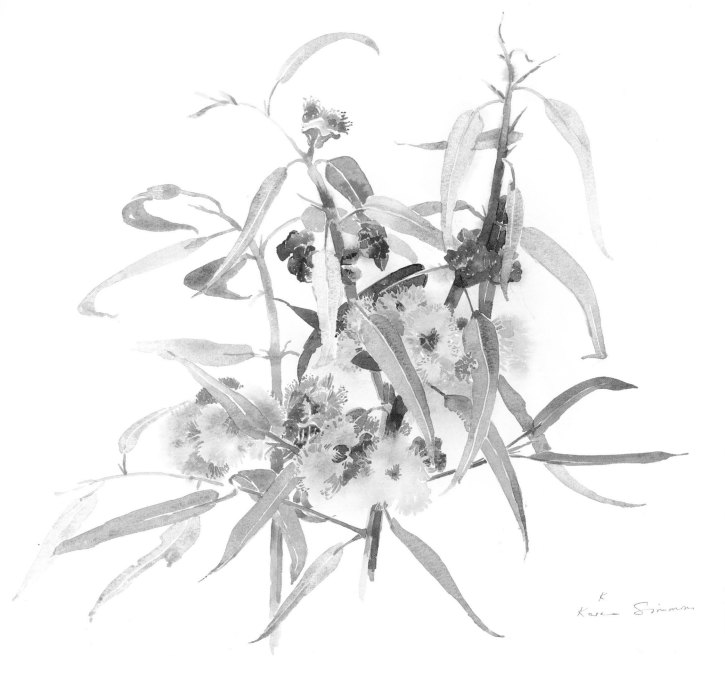

Yellow Gum Blossom

(16 x 19 ½in, 41 x 49.5cm)

I saw this yellow gum blossom in a neighbour's garden while I was staying with some painting friends in Western Australia. The day was far gone when I started, and I began a race against the light, for I was leaving the next morning.

The colouring was unusual: yellow blossom pushing its way out of a scarlet papal hat, the blossoms growing in clusters of four around the red stem, and the fine knife-shaped leaves a lovely grey green.

Colours used: *Aureolin, Gamboge, Yellow Ochre, Cadmium Red, Light Red, Raw Umber, Cerulean Blue and French Ultramarine Blue.*

Paper: *Bockingford 140lb/300gsm.*

Australian Plants

(20 x 16in, 51 x 41cm)

In the painting left, I have painted a few of the amazing plants to be found in Australia. One could paint for many lifetimes and not exhaust the wealth of flowers and plants indigenous to that country.

Colours used: *Cadmium Yellow pale, Cadmium Yellow, Cadmium Orange, Permanent Rose, Cadmium Red, Cerulean Blue, Cobalt and Raw Umber.*

Paper: *Bockingford 140lb/300gsm.*

The Frangipani

The heady fragrance of the frangipani will be familiar to everyone who has lived in a warm climate. Thick creamy white petals spiral from the saffron centre and the flowers bloom in crowded clusters on upstanding stalks while big leaves spread outwards displaying the lovely white flowers to advantage.

I drew the thick-edged petals, the stalks, a few of the big leaves and the stocky trunk of this shrub. Then I flooded the paper with water. I went carefully around the white flowers keeping them dry, brushed the water to the edge of the paper and blushed in some Gamboge around the white flowers. A cool green, made with Cobalt Blue and a trace of yellow, was added to the wet paper. This became the foundation colour for some of the leaves. Returning to the flowers, I wet the individual petals between the curled edges and painted in the Gamboge. I deepened the colour still further at the heart, by adding a little Cadmium Red. A few petals picked up some blue shadows for which I used Cobalt Blue. Some shadows were a mauvey grey and for this I used Cobalt Blue and Permanent Rose, muted with yellow.

The leaves are not pale but the bright down light bleached the colour out. It caused some dark shadows that were cast by the flowers and other leaves. I painted these shadows using French Ultramarine Blue with a little Gamboge. I suggested the evenly spaced veins on the leaves by painting between the fine lines with some more cool and warm greens, but not all the leaves were textured in this way – I left some almost untouched. The trunk was painted with Permanent Magenta, a little Light Red and shadowed with some additional blue.

I now re-wet the area behind the leaves and dropped in a stronger blue green at the top, a warmed olive green in the centre and an earthy colour lower down the page. With these deeper tones, I cut out leaf shapes from the first blush colour. Some leaves are painted within their shapes, but those that are cut out in this manner can look so fresh.

The Frangipani
(16 x 19in, 41 x 49.5cm)
Colours used: *Gamboge, Cadmium Red, Light Red, Permanent Magenta, Cobalt Blue and French Ultramarine Blue.*
Paper: *Bockingford 140lb/300gsm.*

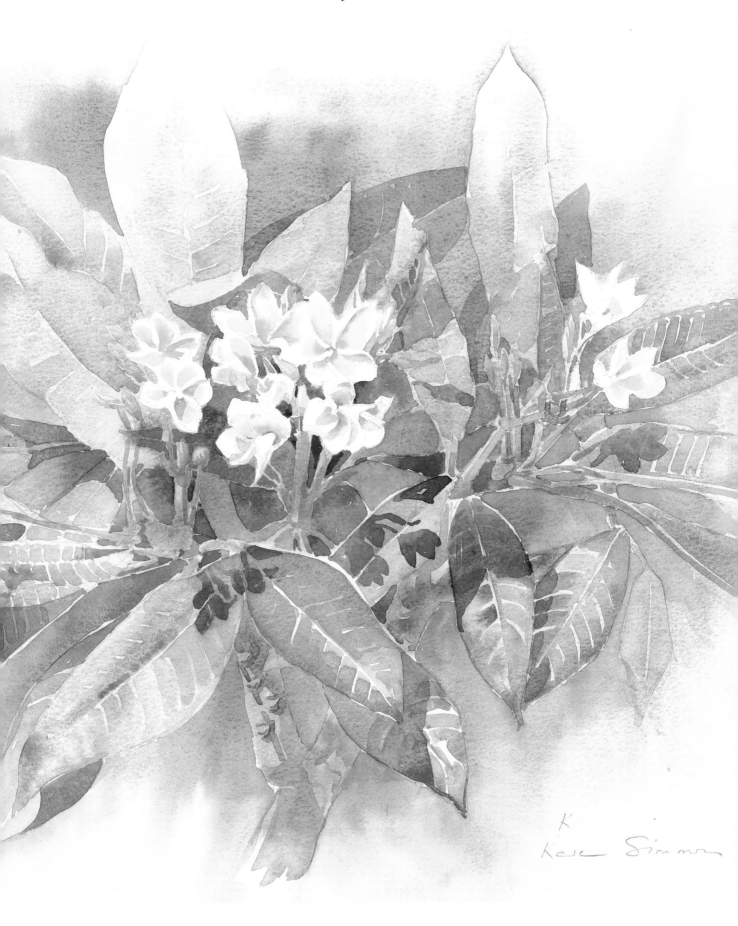

Variegated Thistle

(13 x 11in, 32.5 x 28cm)

Towards the end of a hot Australian Summer, I found this desiccated, twisted, tortured thistle amongst many others in a patch veiled by tall blonde grasses. I am always fascinated by weeds, alive or dead! I emerged from the thicket with this one and took it back to the studio. As usual, it was the exquisite subtle colouring that had called me, and I realised that drawing the thistle would require patience. This thistle is similar to a musk thistle. It has a drooping flower head and thick hooked bracts underneath. These had arched and twisted back from the head, whose silk-fluffed centre was intact. I drew the ribbed stem, boxed the centre fluff, then plotted the bracts from tip to thorny tip. I drew the bracts in their several layers watching the space shapes, observing how they had furled, as they dried, to an ever sharper thorny spine. The thistle had bleached to the palest cream, which reflected other colours in the shadows.

It had been a rewarding study and I could see how some of the elements would lend themselves to a design for a piece of jewellery.

Colours used: Yellow Ochre, Light Red, Raw Umber, Madder Brown, Permanent Rose, Cobalt Blue and Cerulean Blue.

Paper: Bockingford 140lb/300gsm.

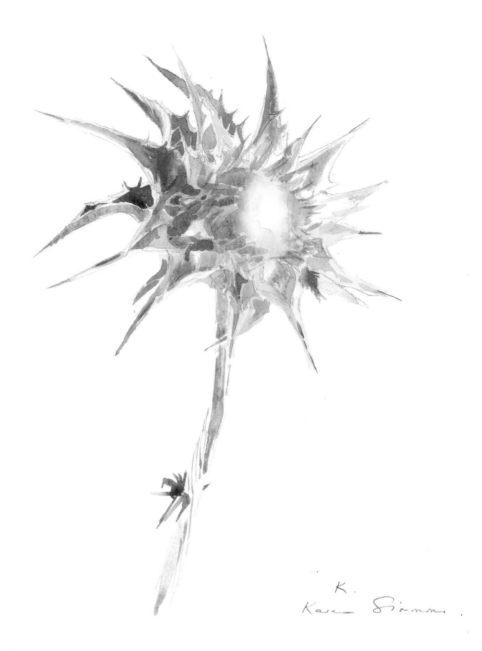

Pomegranates

(20 x 16in, 51 x 41cm)

I saw these luscious pomegranates when I was travelling in Croatia with my sister and a few friends. I looked at the voluptuous pink fruits, well protected by the sharp-spined criss-crossed twigs, the sky blue behind. I needed to paint them! To understand the colouring, I concentrated on the lower left one first, using pure Permanent Rose and Aureolin as foundation colours and enriching this base with Gamboge and Permanent Rose. The thick pointed sepals were a Yellow Ochre edged with a reddy brown, the curly stamens were also brown so I added Permanent Rose to the Yellow Ochre. Seeds have always fascinated me and here I decided to include a study of a section of the fruit.

Colours used: Aureolin, Gamboge, Yellow Ochre, Permanent Rose, Cadmium Red, Cerulean Blue, Cobalt Blue and French Ultramarine Blue.

Paper: Bockingford 140lb/300gsm.

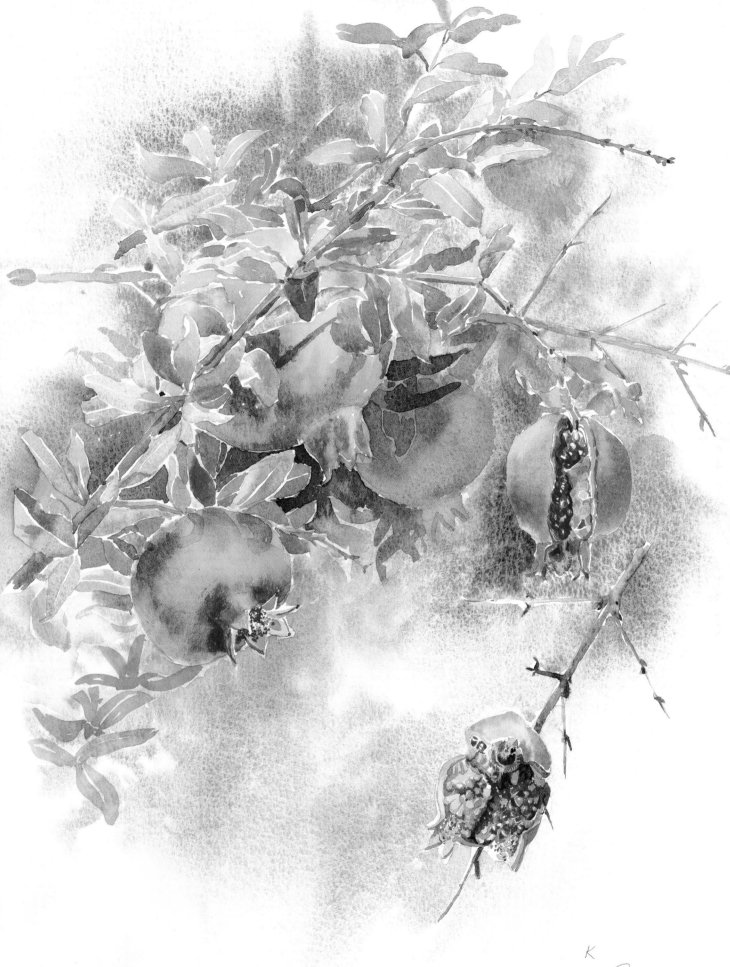

K
Karen Simmons.

The Red Tulip

First I drew the bulb, the bud still nestling deep amongst protective leaves, then I drew the little one with the single leaf and the tall sinewy stem with the tight bud still tinged with green. I planned the full blown tulip with its centre pattern (below), then drew the lovely full tulip bud and stem behind. Well before starting to draw I tried to visualize how it would look in the painting.

I painted the leaves on the first three bulbs, used Cerulean Blue for the sky-related lights, added Cadmium Yellow to achieve the warmer greens and substituted French Ultramarine Blue for the darker greens. The sinewy stem was almost white at the bottom where it emerged from its crisp wrapping and further up it became a fresh yellow green before being tinted with the red of the flower pigment. For the buds, I mixed Cadmium Yellow with Cerulean Blue and applied this first. While this green was still damp I added Gamboge on the edges, then Permanent Rose on the shadowed side and finally the promise of the Cadmium Red. The bulbs had a mauvey sheen to their surface, deepening to a reddish brown and I used Cobalt Blue, Permanent Rose and Madder Brown to shape the bulb.

The big tulip bud was undercoated with Gamboge. Where the light caught the side of the cup, and on the curl of a petal, I used Permanent Rose. I painted over the Gamboge with more Permanent Rose and some Cadmium Red, and allowed a little of the texture pattern to show after the rest was dry.

I also undercoated the full blown tulip face with Gamboge, with the exception of the black centre. When the undercoat was dry, I preserved a border of yellow for

The Red Tulip

(20 x 16in, 51 x 41cm)
OPPOSITE My sister suggested this study of the evolving tulip to me. My original idea was concerned solely with its full-blown face but I am always open to suggestions! I dug up some tulip bulbs and proceeded to paint the different stages, each beautiful in its own right. The full-blown tulip exposed the dramatic pattern at its centre and this invited a closer look.
Colours used: *Cadmium Yellow, Gamboge, Cadmium Red, Permanent Rose, Permanent Magenta, Madder Brown, Cerulean Blue, Cobalt Blue and French Ultramarine Blue.*
Paper: *Bockingford 140lb/300gsm.*

RIGHT A detail of the open tulip flower.

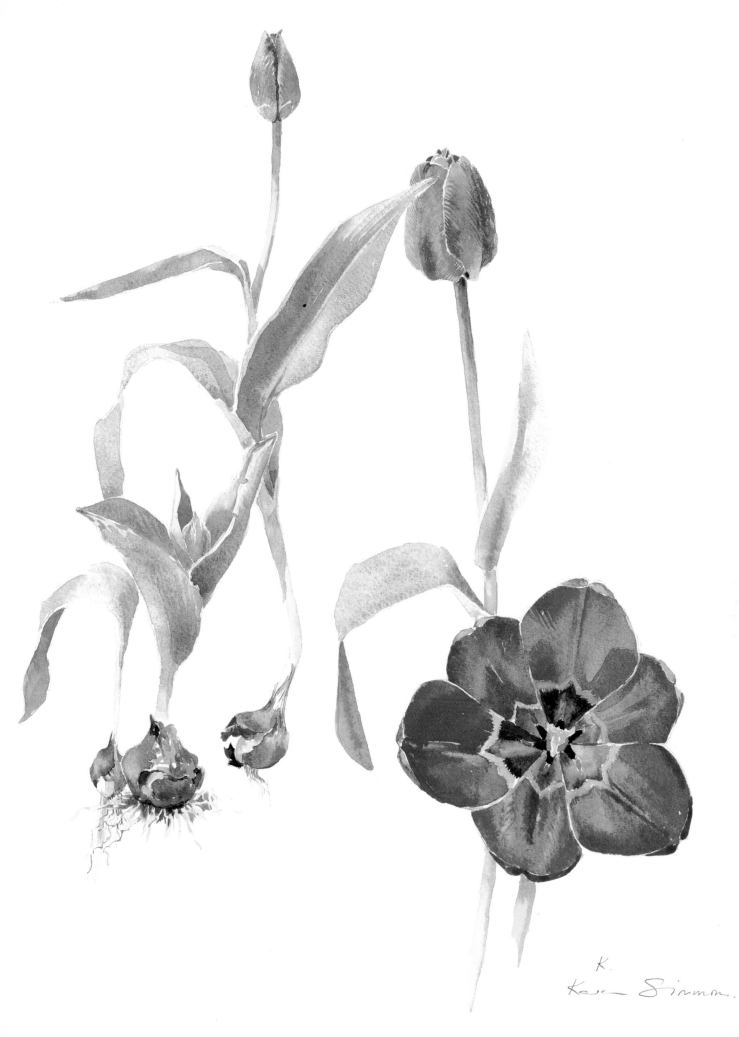

the pattern and painted the bright red petals. I used Permanent Rose for the silk sheen and Cadmium Red for the text, varying the weight of the colour – some thin, some thick. Where a darker red was needed, I added Permanent Magenta to the Cadmium Red.

There was a silky sheen in some parts of the centre and I used diluted Cobalt Blue for this. I used Permanent Magenta combined with French Ultramarine Blue to describe the black, and by adding Cadmium Red to that mixture I made an intense black for the six filaments and used a pale yellow green for the stigma. I was so fascinated by the centre that I studied it under a magnifying glass.

Palette for centre pattern of *The Red Tulip*

Gamboge glazed with Cadmium Red

Gamboge

French Ultramarine Blue Permanent Magenta + Cadmium Red

French Ultramarine Blue + Permanent Magenta

Cobalt Blue + Permanent Magenta

Raw Umber + Gamboge

Gamboge

Madder Brown + Cadmium Red

Cadmium Yellow Pale

Centre Pattern of the Tulip

(17 x 16in, 42.5 x 41cm)
OPPOSITE I painted the pattern from the centre of the tulip, simplifying and magnifying it. When I had completed it I was struck by how Islamic the pattern seemed and realised that tulips originated in Turkey.
On this page I show the palette I used. I defined the pattern with fine ink lines.

Sea Holly

(15 x 12in, 38 x 30.5cm)

This was painted from a black and white photograph which had been taken looking down directly over the sea holly. I took the colour information from some real sea hollies.

The shape and proportions were perfect: it was exquisitely beautiful. One could imagine a sumptuous piece of jewellery being designed from this source.

Colours used: *Cerulean Blue, Cobalt Blue, French Ultramarine Blue, Permanent Rose and Raw Umber.*

Paper: *Bockingford 140lb/300gsm.*

Banksia nut

Detail magnified

Banksia Nut

This is what is left when the Banksia bloom is well over. It looked to me like a piece of intricate wood carving; carved beading on a frame could look like this, and oriental furniture could well be decorated with such a rich and complicated pattern. I was so intrigued I drew a section using a magnifying glass; it was fascinating and beautiful. So often when we think we have invented a new design or pattern, we find that nature has been there before us.

Giant cow parsley

Enlargement
of one seed

Poppy seed heads

Enlargement of poppy seed seen from above

Giant Cow Parsley

Here I have drawn a study of the flower heads, with an enlargement of one seed.

Poppy Seed Heads

It is always rewarding to look closely at seeds and the poppy seed is particularly fascinating. At the top you can see a series of gothic arches; inside, the ceiling is vaulted! (Was our architectural development conscious or unconscious?) I am reminded of the onion-shaped church steeples of Southern Germany and Austria. The poppy seed also lends its faceted sections to these designs.

Supporting the head on the stem is the slim concave neck that adds such grace to the whole. The ribbed platelet at the very top still held a few of the seeds when I picked it up and more seeds cascaded from between the arches when I tipped it on its side.

Berries

(14¼ x 14in, 35.5 x 36cm)

At the time of writing, I have still not managed to identify this plant. I painted it in Florida and have also seen it in southern Styria in Austria. Its attraction for me was the amazingly bright magenta stems together with the dark purple black fruit. It is a shrub-like weed which, *en masse*, is quite dramatic in its colouring. When the berries have gone, the abandoned sepals look like little magenta flowers. It is best painted where it grows as it wilts disastrously when picked.

I drew the berried stems and leaves with some care before painting, and used Permanent Magenta and Cadmium Red for the stems, and Permanent Magenta and French Ultramarine Blue for the purple berries – when I added Cadmium Red I achieved a black. By mixing some green into the magenta I came across the colour I needed for the half-ripe berries. The leaves, well chewed, were a fresh green, some already turning to yellows, pinks and browns. I was fascinated by the juxtaposition of these colours and enjoyed studying and painting this plant.

Upside-down Hydrangea

I started by plotting the overall shapes, then drew the florets with care, and also drew the fascinating coloured glass stems (see overleaf). I painted the two heads in different ways: the large one I treated as a study, so I did the florets carefully one by one; and I painted the smaller head in a softer impressionistic way so that it would recede a little.

The attraction of a hydrangea is that the colour, whether blue or pink, is not evenly distributed. Each floret has its own identity while being part of the whole. The outer petals on the larger head were very pale. I used diluted Cobalt Blue for some, and Cobalt Blue combined with Permanent Rose for others. Cerulean Blue was used when a petal had a turquoise colour. Once I had applied the paint to the petal, I could drop a stronger colour in to shape or shadow it. Some of the florets had a greeny yellow colour, and for these I used Cadmium Yellow pale, very diluted, and let a little Cobalt Blue bleed in.

Where shadows were needed, the colours were deepened by using less water. The shadow colour could show the edge of a lighter petal to advantage. The little centre button was sometimes blue, sometimes a vivid green. Most of the buttons were not yet open, and the ones that were became yet another flower with tiny fairy antennae.

Before painting the interior of the cave, I painted the glassy stems with their pigments of turquoise and blue. Some vials were an intense blue, for which I used French Ultramarine Blue, sometimes combining it with Cerulean Blue, other times with Permanent Rose.

I achieved a fresh green for the green stem and leaves by mixing Cadmium Yellow pale with some Cerulean Blue. The stem showed some pigmentation and markings, and I used a little of the purple I had made with French Ultramarine Blue and Permanent Rose to blend in with the green or on its own for the markings. Finally I put in the shadowed florets in the interior of the cave using a stronger purple and blue mixture.

When I painted the smaller head, I wet the area, taking the brush into the petal profile, then I bled in various blues and pink mauves. I deepened a few of the turquoise centres with Cerulean Blue. When this stage had dried I deepened again behind some of the florets and petals, and painted a deeper tone between the coloured stems for the dark interior.

When it came to the shadows on the surface, I wet a generous area from the base of the flower outwards, and made a grey using the colours from the flower. I dropped the colour in close to the head letting it disperse away. One grey was a blue grey, for which French Ultramarine Blue, Permanent Rose and a little of the mixed green were used. The smaller head was shadowed with a similar mixture where the Permanent Rose with the green dominated.

Upside-down Hydrangea
(12½ x 20in, 32 x 51cm)
OVERLEAF Hydrangeas are almost more attractive upside down than the right way up! From that angle you can observe the finely coloured branches reaching from the stem to each flower; they look like glass cylinders filled with coloured ink. The colour is intensified in the hollow curve of the flower. I had long wanted to paint this aspect, but once started you must continue as hydrangeas do not like being out of water for long.
Colours used: *Cadmium Yellow pale, Permanent Rose, Cerulean Blue, Cobalt Blue and French Ultramarine Blue.*
Paper: *Schoellershammer 140lb/300gsm.*

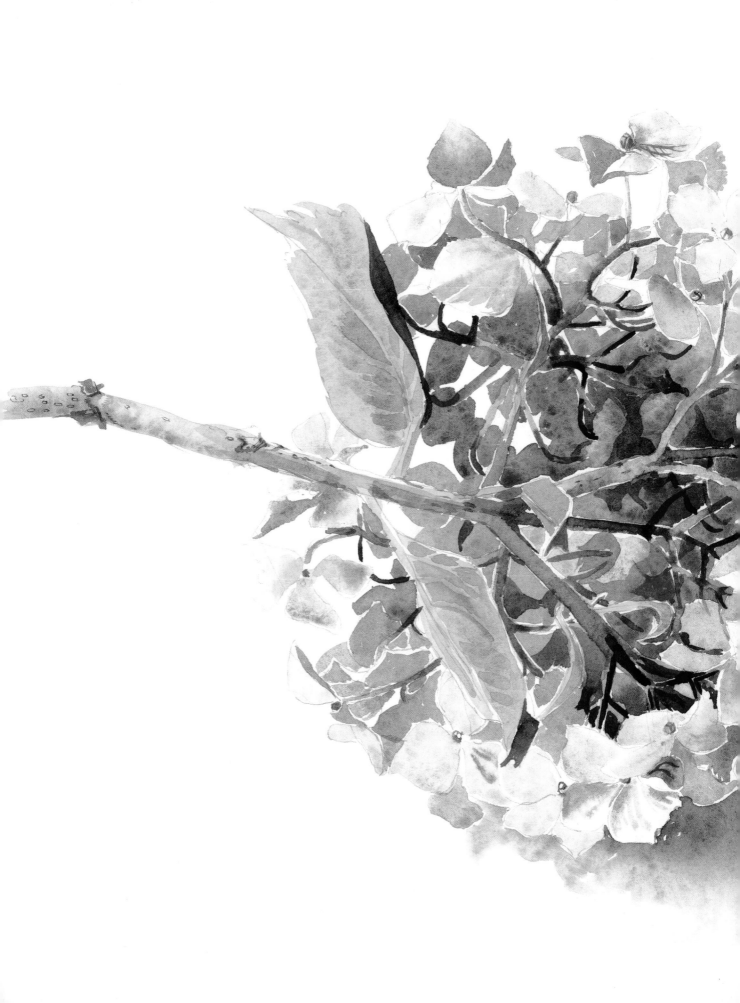

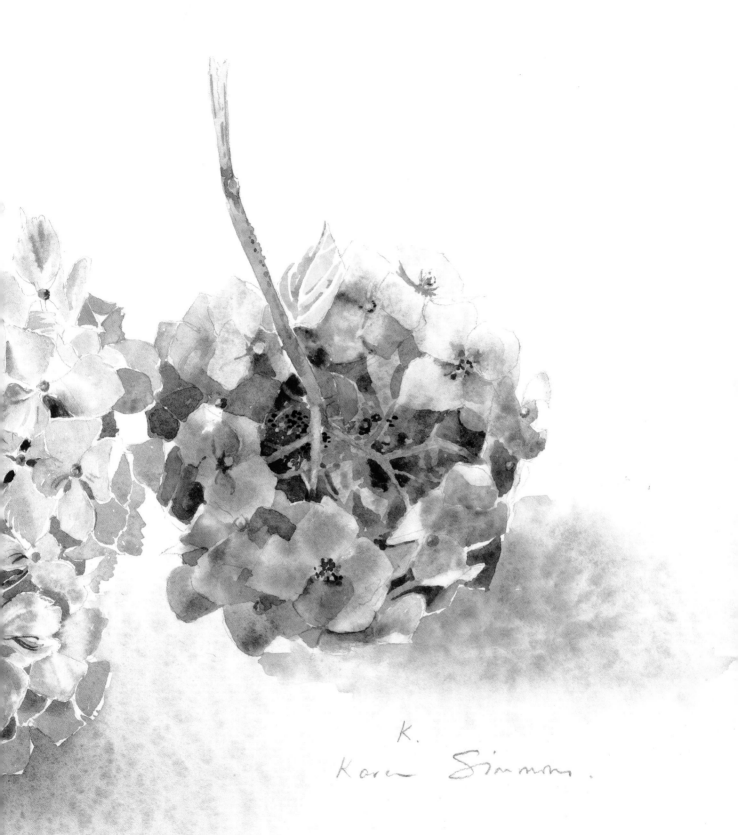

K.

Karen Simmons.

Conclusion

Flowers and plants are part of our everyday consciousness. We like having them around us indoors or outdoors, and they play an important part in our lives. We give flowers to each other at times of celebration, or of compassion, or simply to give pleasure. It is not surprising therefore to find that artists have been aware of them as sources of inspiration for thousands of years.

Flowers and plants have played a part in Chinese art and Indian art, and designs from flowers have been abstracted in Islamic art. They have acquired symbolic meanings in various cultures and religions, including Christianity. Artists have used flowers and plants to decorate ceilings and panels in the interiors of churches and palaces. Flower motifs, interlacing leaves and stems have embellished manuscripts and bibles, including the beautiful Lindisfarne Gospel and the Book of Kells, as well as many devotional books.

Our own interiors today reflect this ongoing response to flowers and nature. Wallpaper designs and fabric designs draw from the same source, and handles on drawers and cupboards are often decorated with flower-sourced designs. We follow a long tradition of artists who have painted flowers, including Monet, van Gogh, Emil Nolde, Albrecht Dürer, Leonardo da Vinci, the Dutch flower painter Jan van Huysum and we dare to paint!

In this book I have concentrated on some of the hazards that can arise when attempting this challenging subject and have tried to give detailed, useful solutions to them. Because colour plays such an important part in flower painting and because I enjoy colour so much I have explored and exploited what watercolours can do. Painting in watercolours is like driving a very fast and powerful car – it is exhilarating to let the colours fuse and blend on the paper, yet stay in control!

I have included examples of flower subjects I have found around me at one time or another and could have included many more. The purpose was to share this awareness with you, to widen the range of subjects that can be sourced and inspired by flowers. Let me leave you with this wonderful, and to me totally proven, quotation by Marc Chagall: 'Art is the unceasing effort to compete with the beauty of flowers – and never succeeding.'

OPPOSITE **The Star Inn with Friends, Waldron**
(20 x 16in, 51 x 41cm)

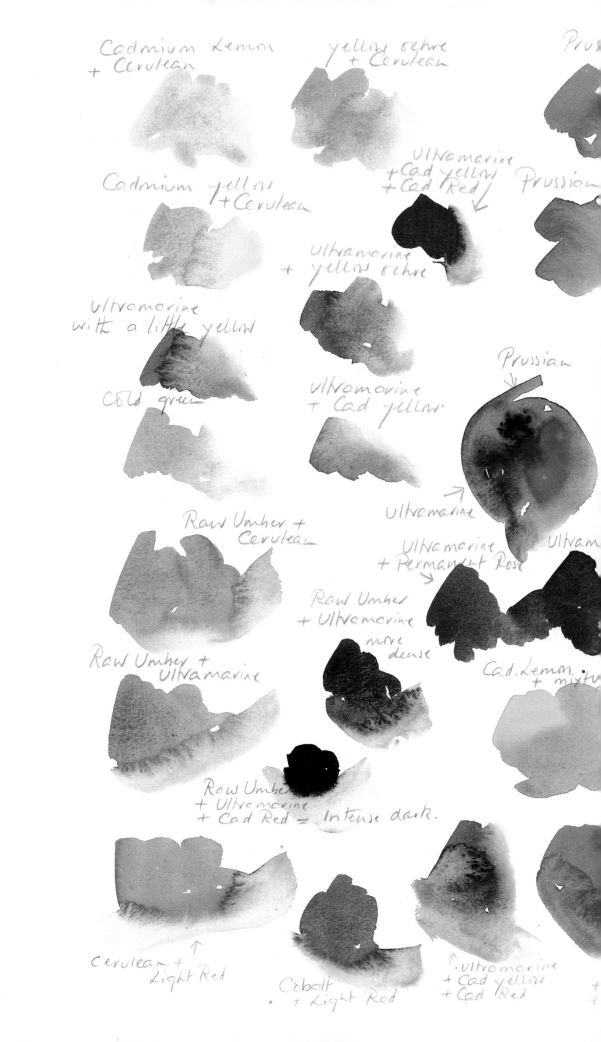

Cadmium Lemon
+ Cerulean

yellow ochre
+ Cerulean

Prussian

Cadmium yellow
+ Cerulean

Ultramarine
+ Cad yellow
+ Cad Red

Prussian

Ultramarine
+ yellow ochre

Ultramarine
with a little yellow

Prussian

Ultramarine
+ Cad yellow

Cold green

Ultramarine

Raw Umber +
Cerulean

Ultramarine
+ Permanent Rose

Ultram

Raw Umber
+ Ultramarine

Raw Umber +
Ultramarine

more
dense

Cad. Lemon
+ mixtu

Raw Umber
+ Ultramarine
+ Cad Red = Intense dark.

Cerulean +
Light Red

Cobalt
+ Light Red

Ultramarine
+ Cad yellow
+ Cad Red